RECIPES FOR SURVIVAL

Maria Thereza Alves

Foreword by Michael Taussig

University of Texas Press · Austin

FOREWORD

MICHAEL TAUSSIG

In 1983, at the age of twenty-one, Maria Thereza Alves traveled from New York City to visit the village of her father in the Brazilian state of Paraná and then the small town of her mother in the state of São Paulo. Maria Thereza had been living some years in New York City and was a junior studying photography at Cooper Union. She took her camera, took pictures of people, and wrote this book in which each word seems chiseled in stone: so dry, so refined, so immensely moving that I thought of Walter Benjamin's reference to Herodotus, whose drier-than-dry, unsentimental cryptic stories beg neither theory nor psychologizing nor explanation. They just are.

How a slip of a girl, aged twenty-one, could write such a text, let alone make such intense photographic portraits, is unfathomable. She says she wrote it in one shot from notes shortly after visiting. No doubt the photographs played a crucial role in the writing. But what alchemy was there at work in this historic encounter between this kid who shows up one day, whose parents made it to the United States, and her subjects. She is an insider and outsider with an almost wicked eye for human frailty, hypocrisy, and the terrible, grinding injustice running through every damn thing big or small.

Was there ever a book like this that says so much about the world in so few words? It is almost frightening, this shock treatment, little darts that swarm through the stimulus shield you have spent a lifetime cultivating. Perhaps it is the apparent simplicity that does this—that and what I can only call "authenticity," meaning the integrity aroused by a shockingly level-headed confrontation with life. Dostoyevsky comes to mind—the grain and the pathos—as does Primo Levi's account of Auschwitz; James Agee and Walker Evans's American classic, *Let Us Now Praise Famous Men*; and John Berger's work with photographer Jean Mohr.

It is an integrity bound to the evocation of those whom Frantz Fanon called "the wretched of the earth." It is the integrity of an encounter, the purpose and being of which insists on an empathy yet also on a critical distance that allows unalloyed truth to emerge sharp as a knife. It is the integrity that can come about when one is witness to the flicker of life in the great darkness of being.

But above all, it is the integrity created by the flicker of life in the almighty darkness where art and documentary coalesce. For it is breathtaking, the way this book works; you realize, if barely consciously, that what it portrays is counterweighted by the mode of portrayal, the power of which feeds back into what it portrays.

This implies an X-ray of the species and a caressing of the wound that is history. This means an eye ever alert to political economy and the moral force of sex and human relations, but more than that, an eye geared to moral codes and the cunning of their subversion. Like the work of Dostoyevsky, *Recipes for Survival* brings the darkest and smallest aspects of everyday life to the surface in a matter-of-fact and almost affect-less way. Rain falls. Rain doesn't fall. Crops are ruined. The local money lender who owns the village store gets your land or else the banks do (peasants need money to buy fertilizer for tired fields), and husbands beat wives for no reason or for a reason like they danced with other men. One woman asks a younger one, "Have you seen a man naked? It is not a pretty sight." The author's photographs show people barefoot in the fields. The schools have posters of kids in showers and toilets, but these facilities are otherwise unknown, as is the word "silk." Yet, there is TV. You have to have a state-issued "workbook" without which you are in trouble, but in which the employers write what they like. A multinational denudes and replants the forest with foreign species such as North American pines and Australian euca-lyptus trees, which the local wildlife avoids so people call it "the silent forest." Dark skin color and Indian features are a constant preoccupa-tion. A young boy beats his grandparents who raised him. They drink a lot. The grandmother tried to drown him when he was small. He kills things. He spends a day gathering pretty shells. Then he smashes them. He races the author through the forest. He wins the race and feels good. Domestic interiors and the machinery of a small sugar mill are described in intimate detail as an architect or a mechanic might do. This is the scaffolding of the world, and the words used here are an essential part of that scaffold, too. An old woman who had eleven

children and was beaten frequently by her husband says she is glad she saw him die, and you are left to wonder what that means. Only one of her eleven children visits her. "I have suffered much in this life," she says. "Now I am good for nothing. I cannot work. I cannot piss. I cannot shit. There is no reason to stay here."

These are the last words in this book you hold in your hand.

There is a terrible bitterness here, a portrait of overwhelming odds. Only a wide-eyed yet astonishingly mature twenty-one-year-old could traverse the moral incline involved in the "return" to "source," from Global North to Global South. It is a miracle. It is Dante as girl with a camera, this journey, but this inferno will not yield much to the divine nor to the comic.

"There is no reason to stay here."

It is a very great achievement in sociological portraiture, side-stepping the suffocating aporias that are so fashionable in intellectual work nowadays, while keyed to the cliff-hanging paradox that hovers between the absurd and the real.

Is this the photographer's eye, I ask myself? Is this the visual image rendered in the language of close-up description of things combined with stories in prosaic speech?

The bodies in the photographs: they are astonishingly thin, but more than that, sinewy, taut, and elastic, graceful even when misshapen. Like ballet they are, ballet frozen in time, space, and, above all, in the imagination. It is you in your body who will catch this and complete the movement. And this is the writing, all of this, taut and sinewed, that will catch you too, so as to complete the movement.

As for the faces, like Emmanuel Levinas said, "the face is the evidence that makes evidence possible."

This book is not just that evidence. It is the very idea of evidence itself.

RECIPES
FOR
SURVIVAL

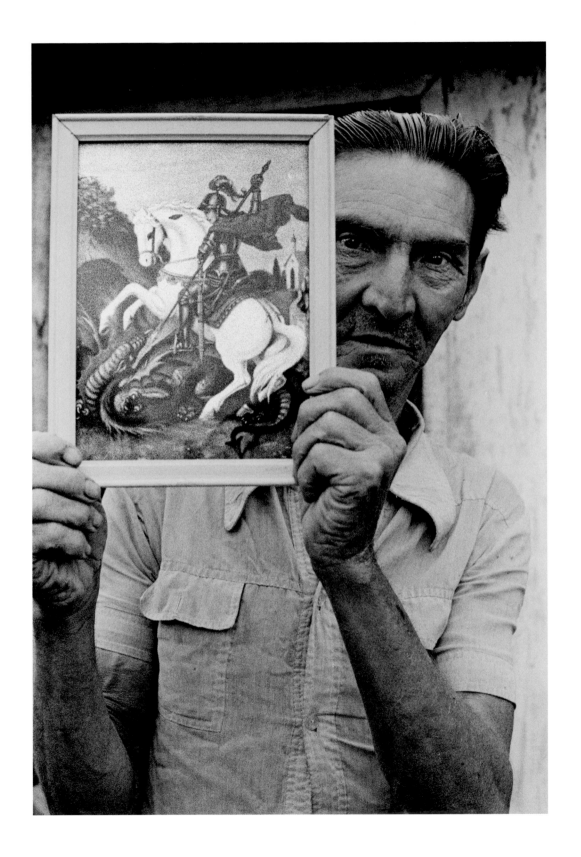

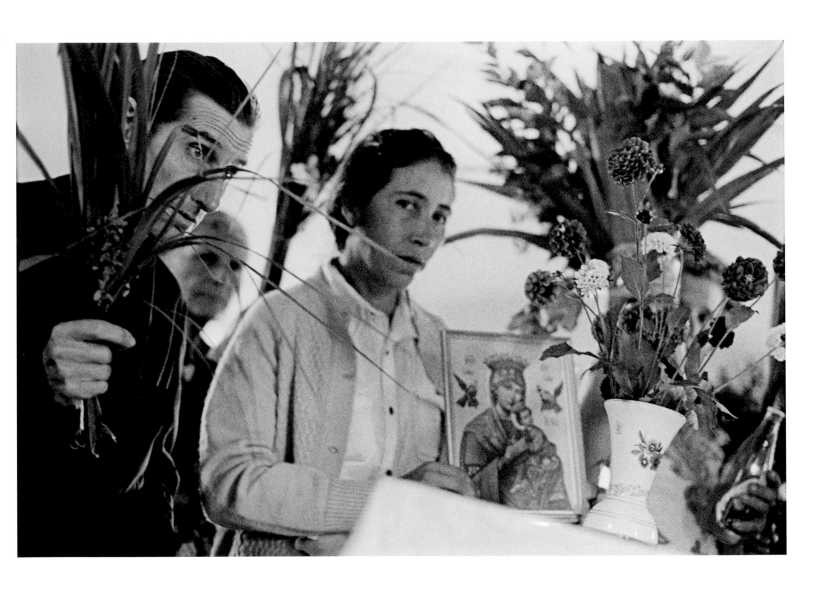

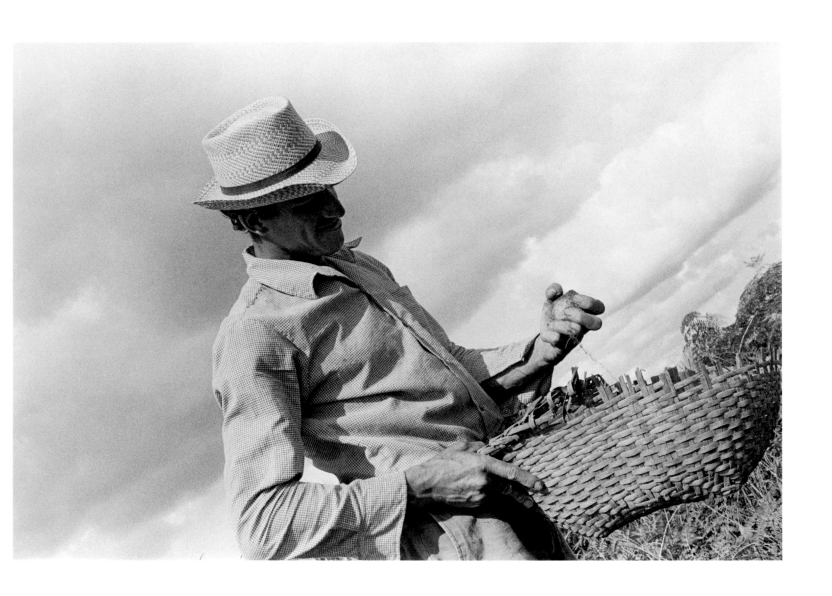

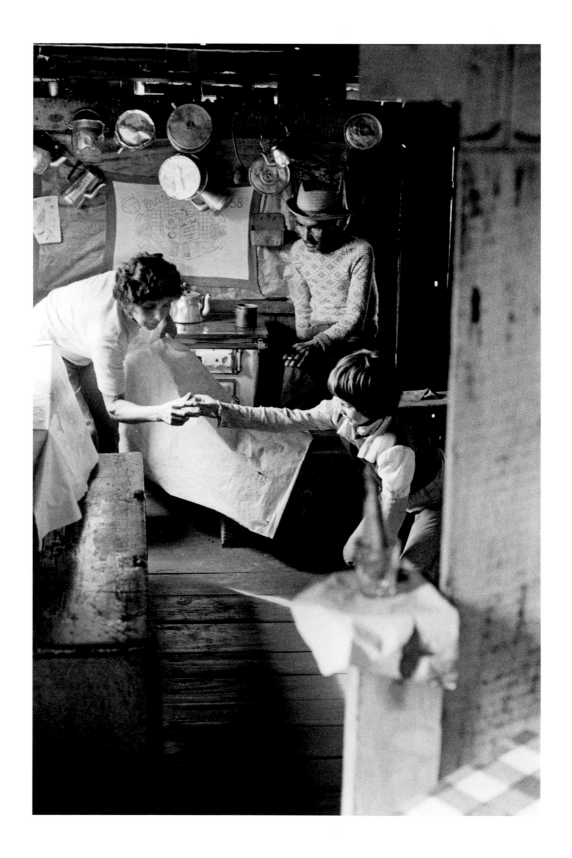

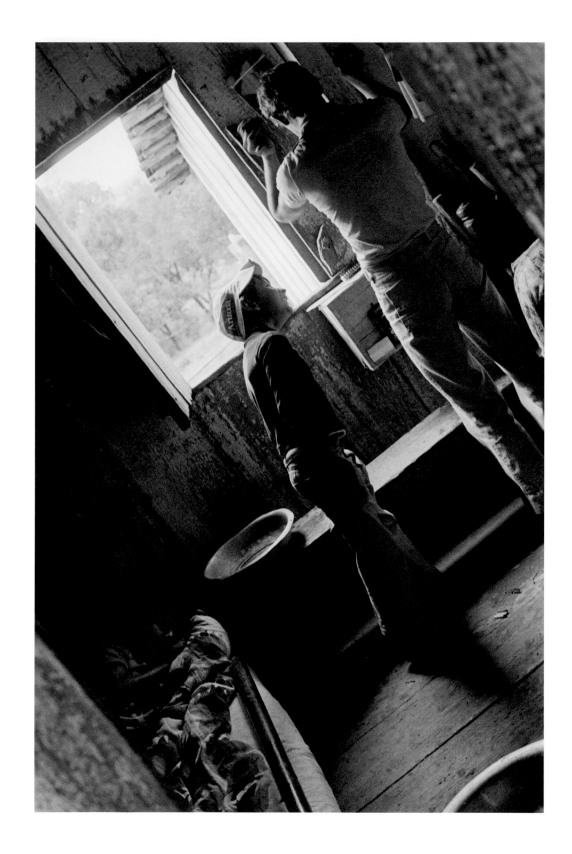

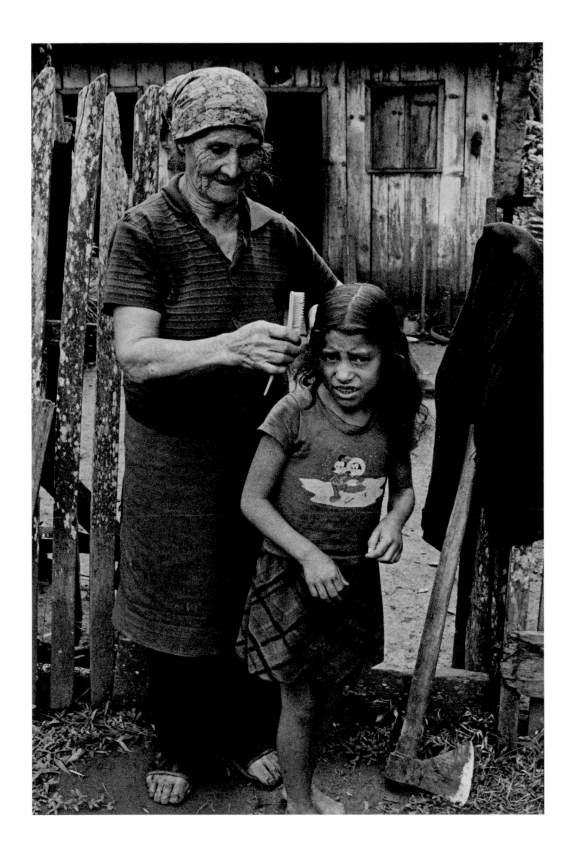

13

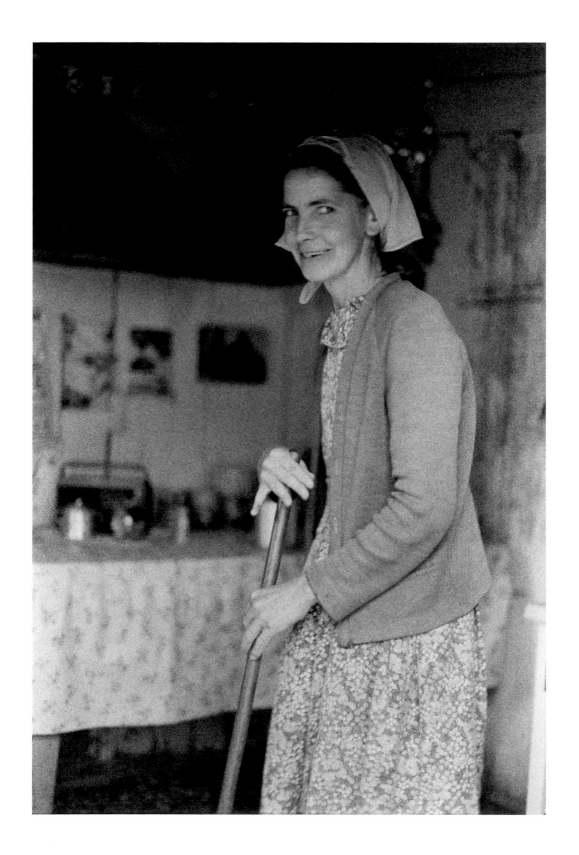

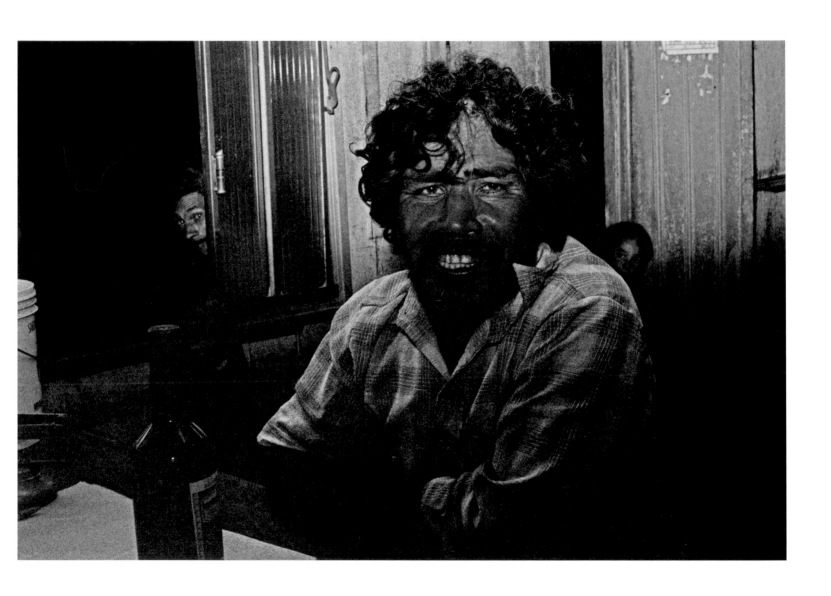

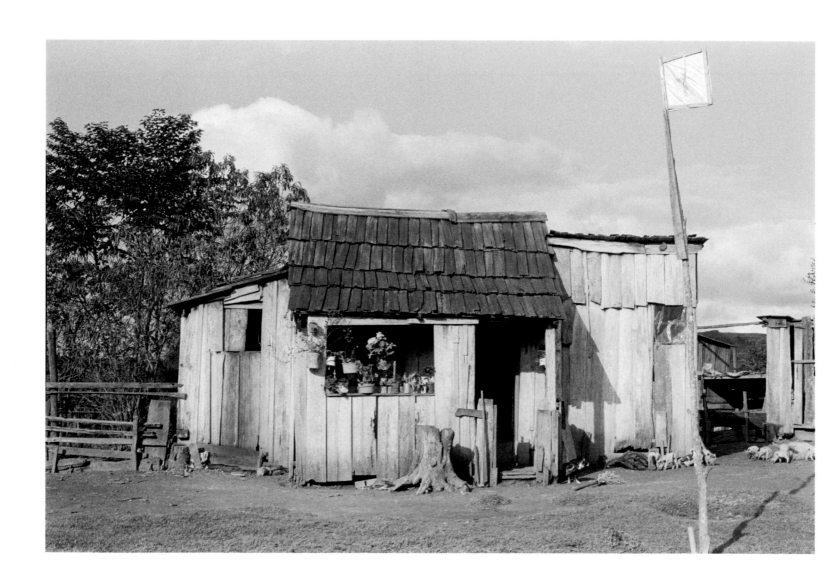

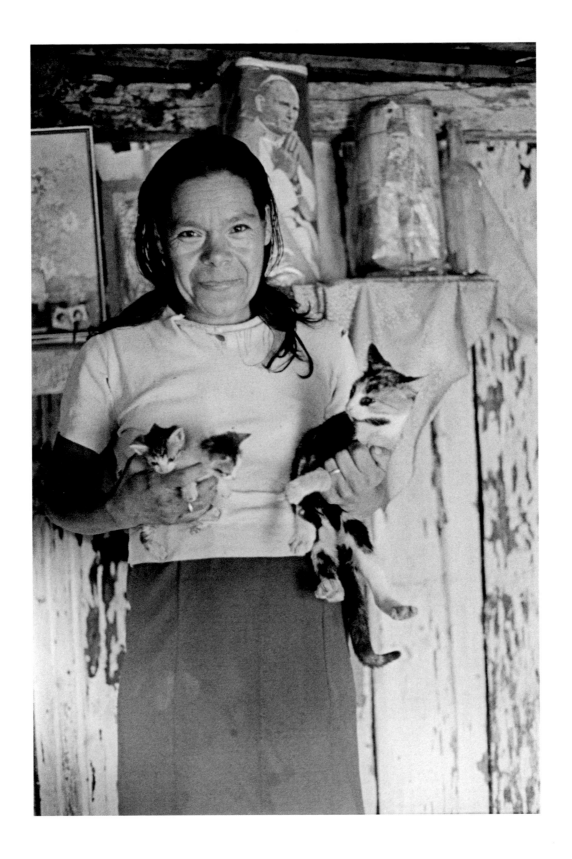

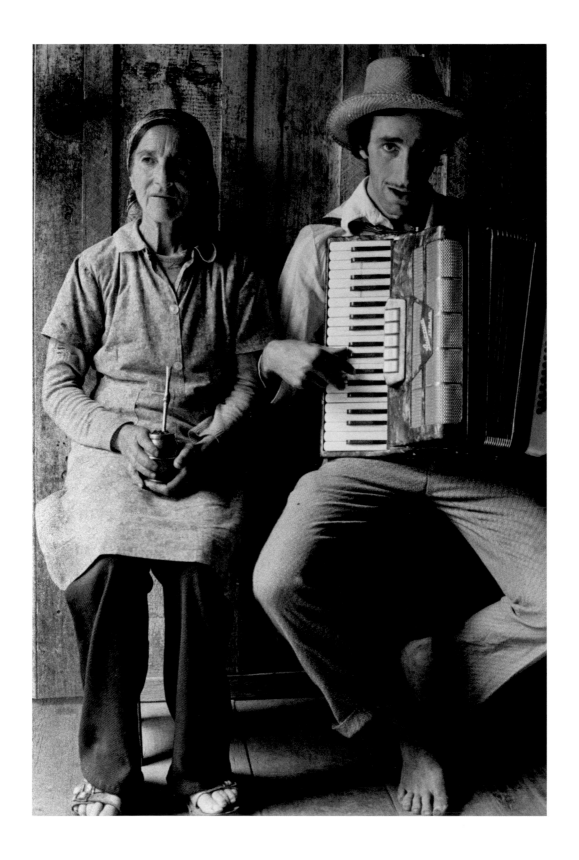

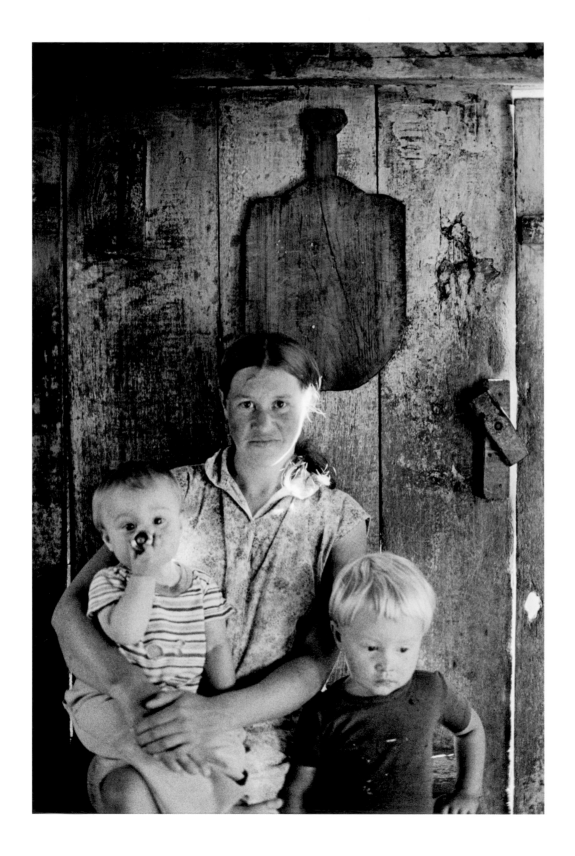

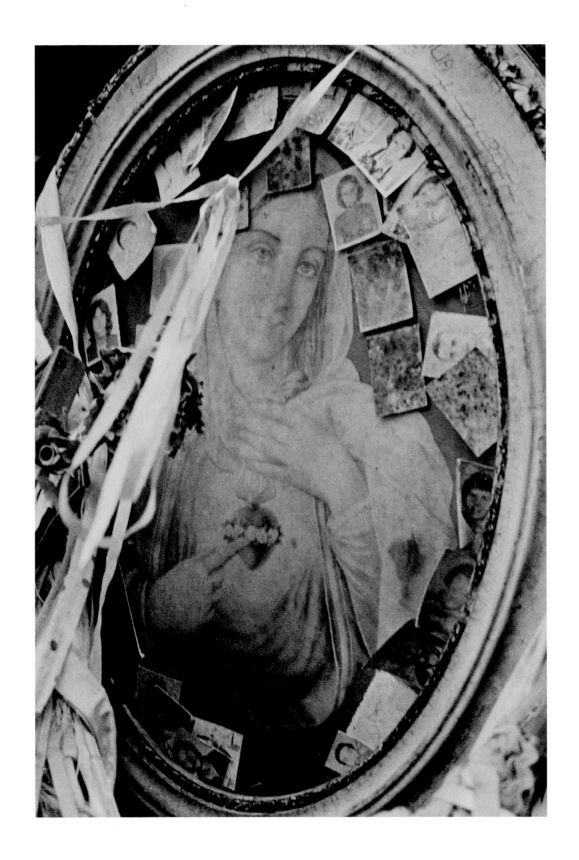

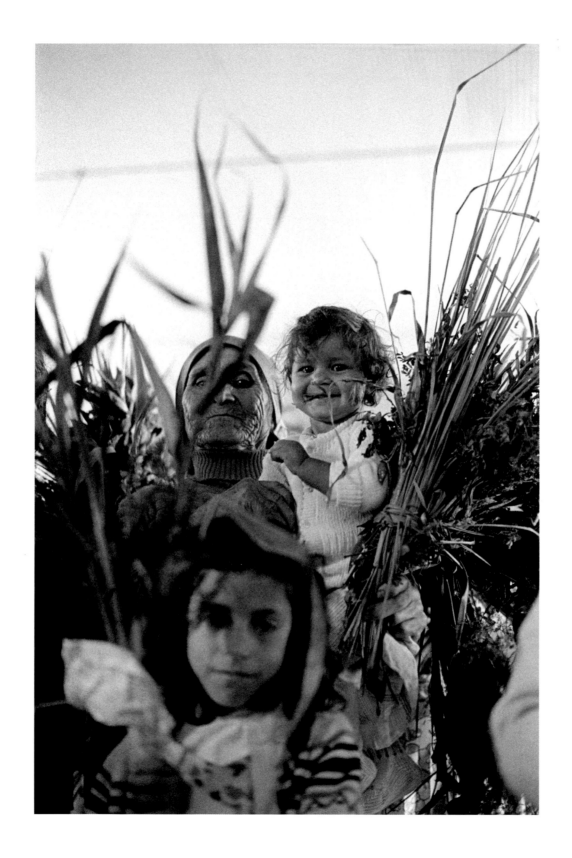

28

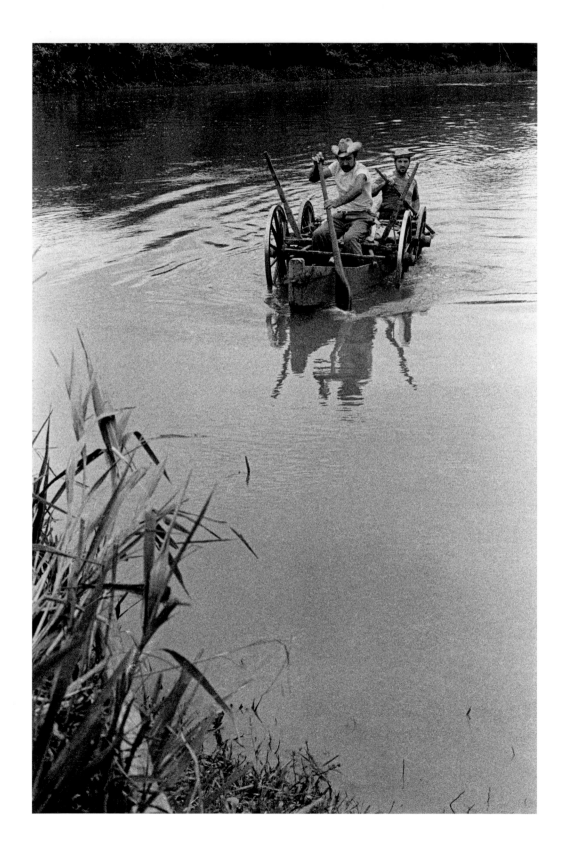

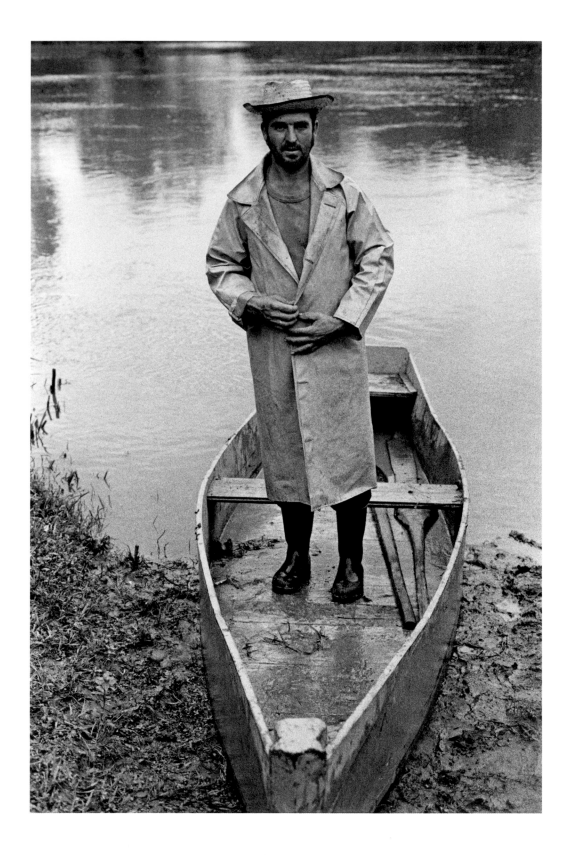

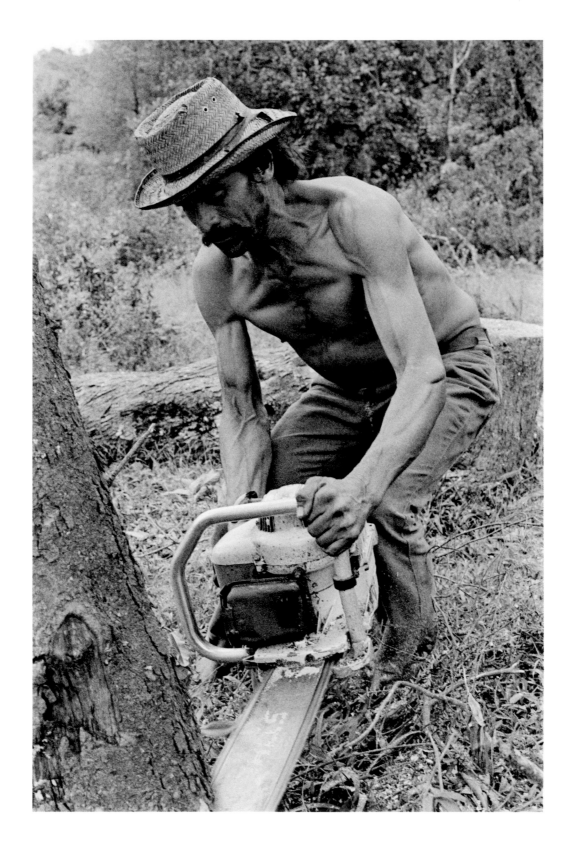

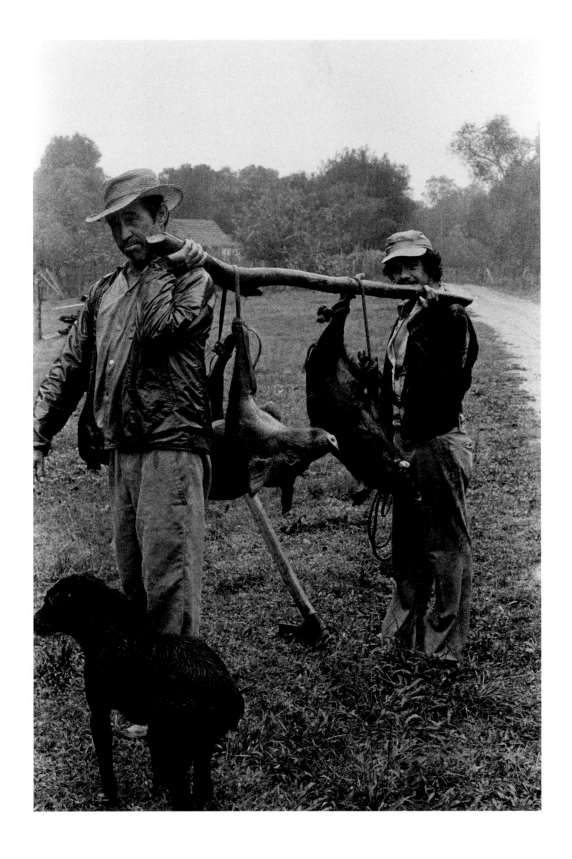

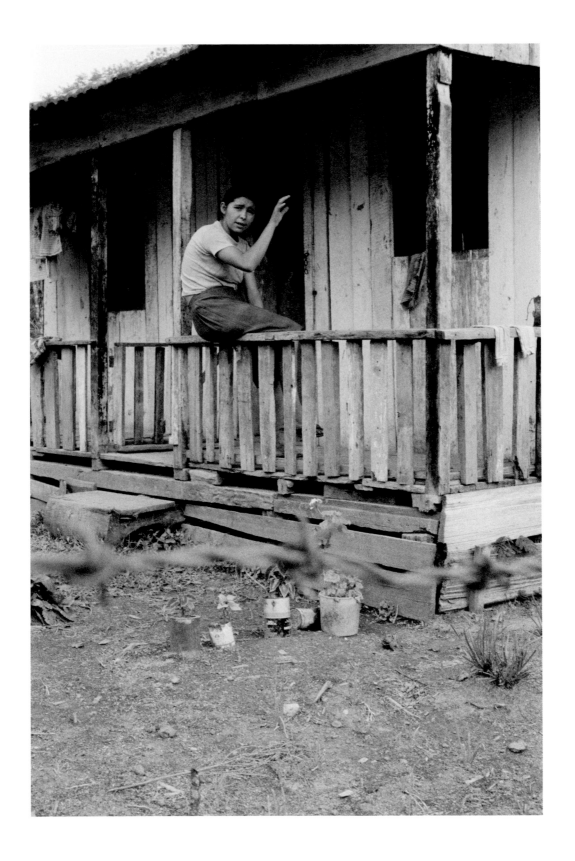

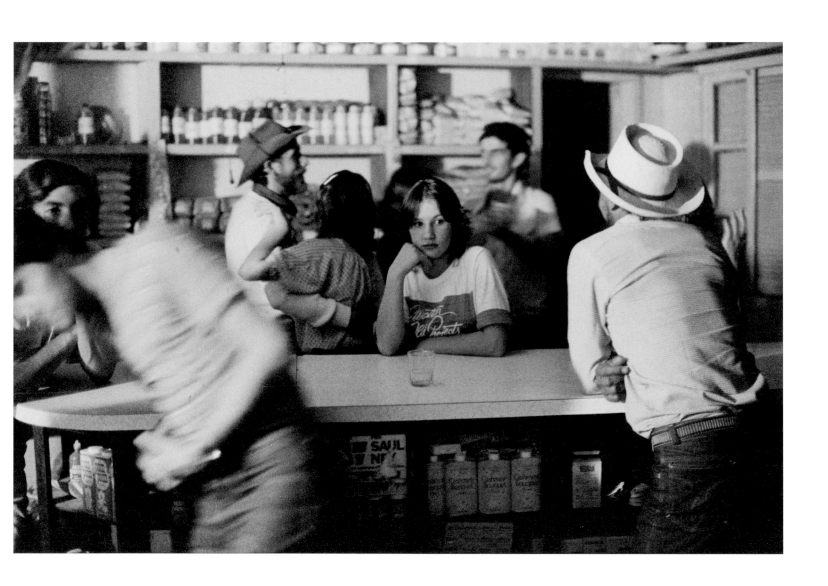

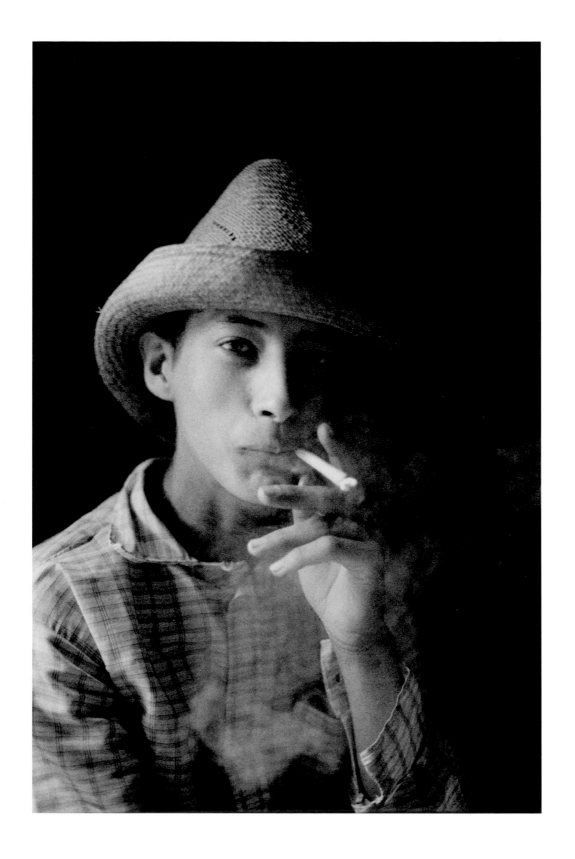

41

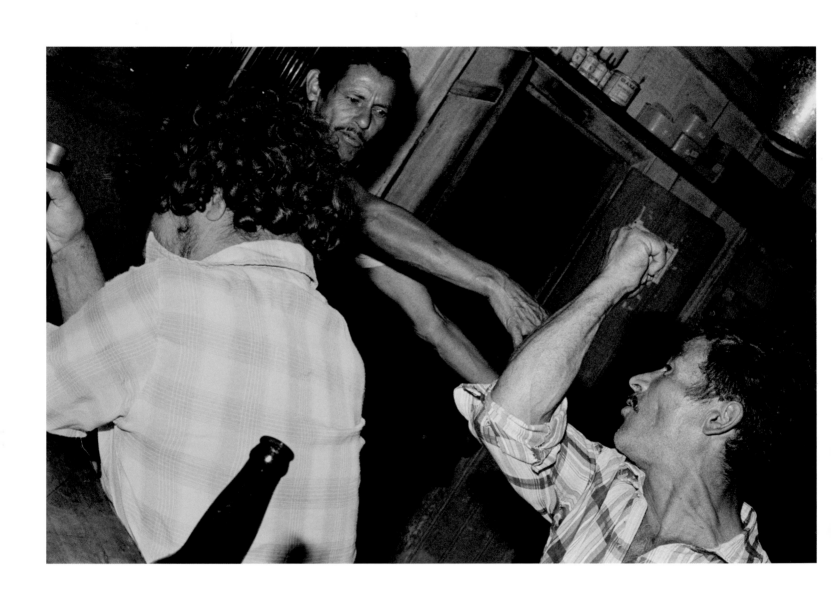

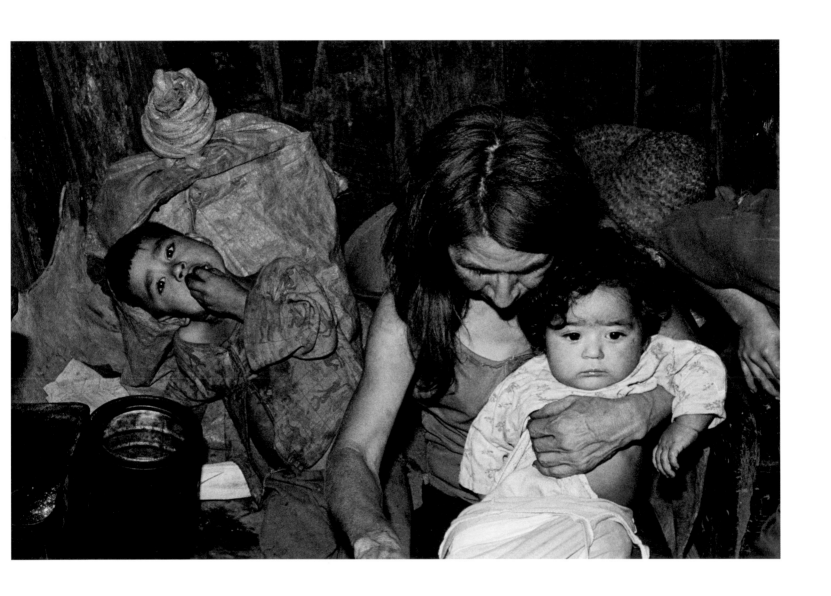

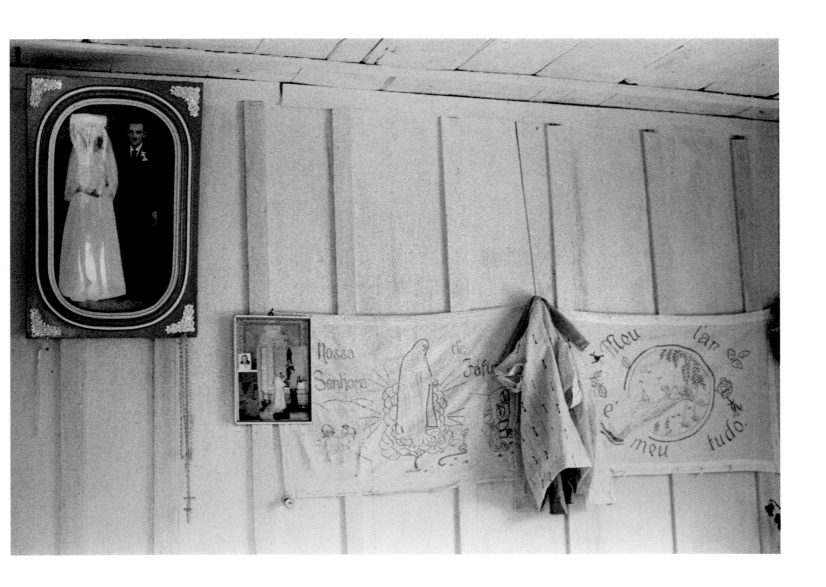

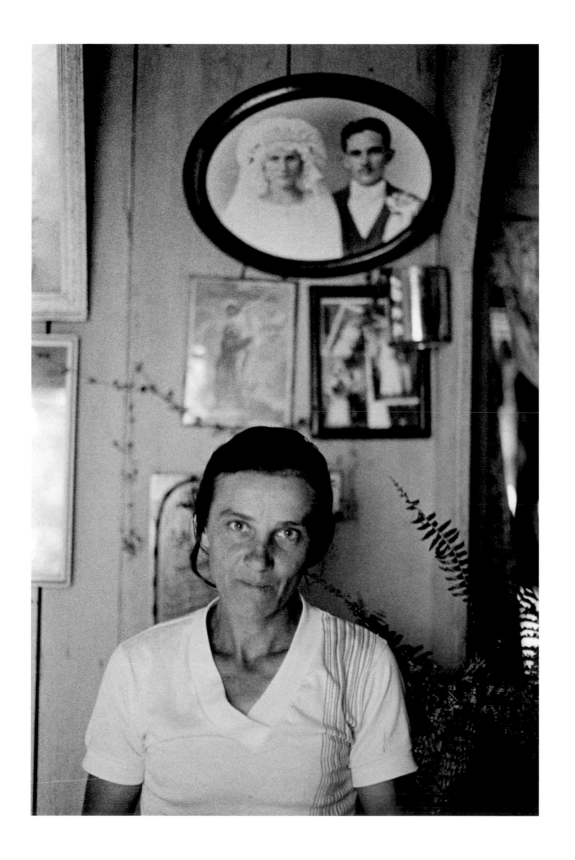

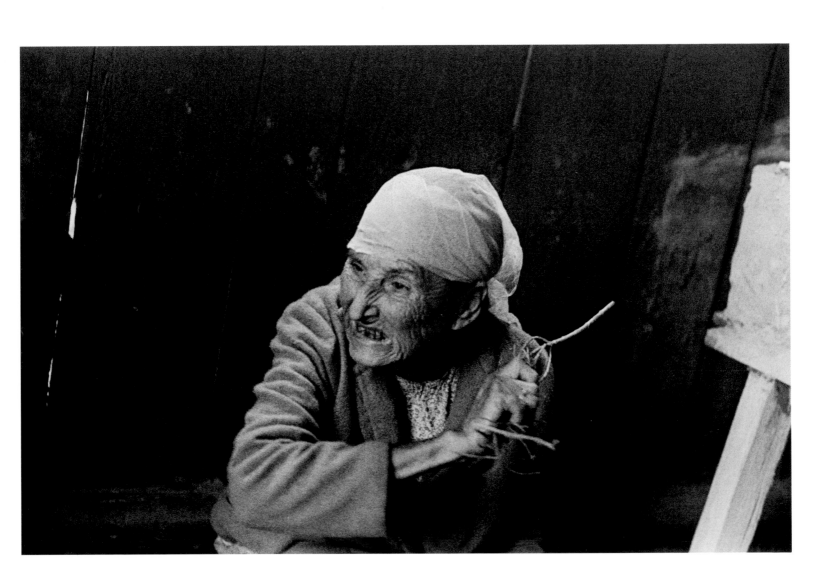

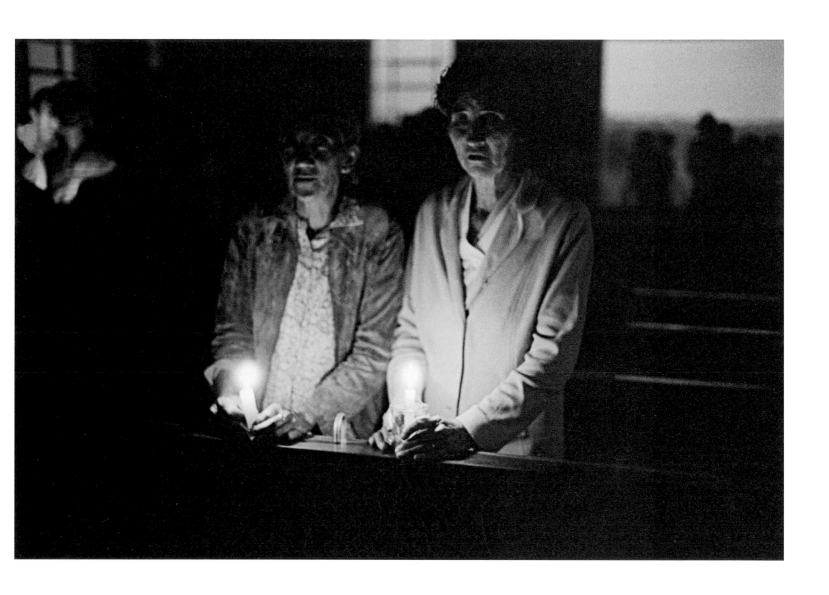

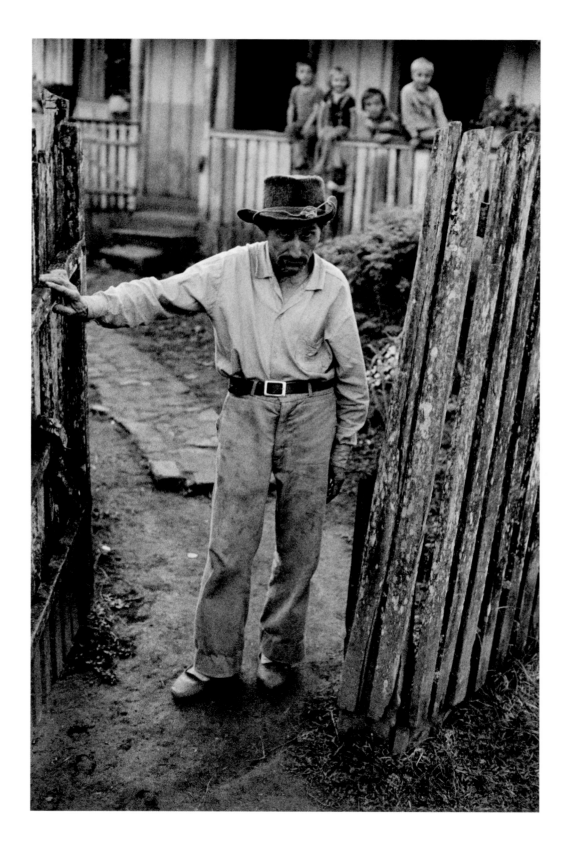

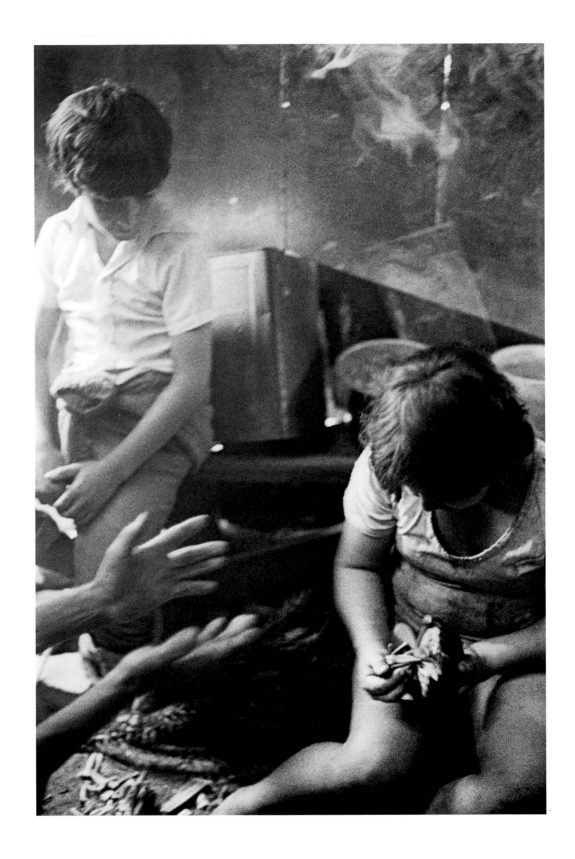

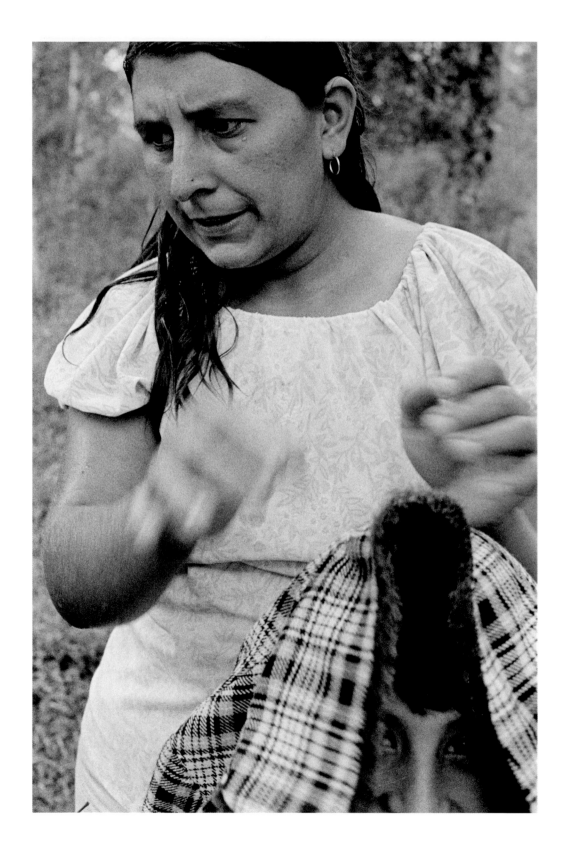

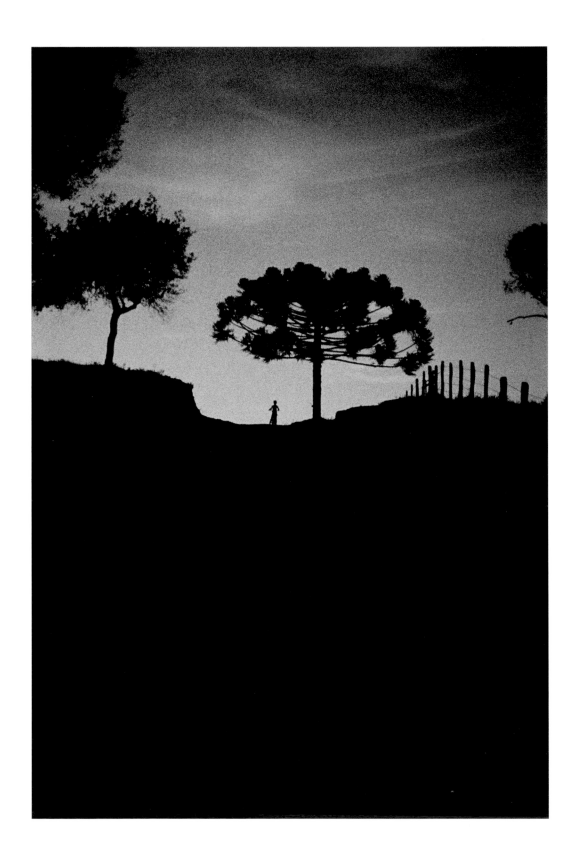

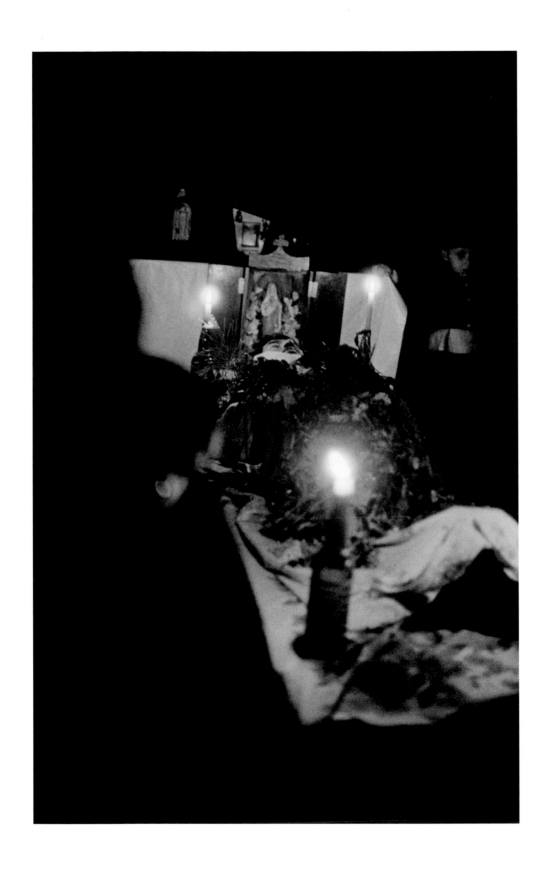

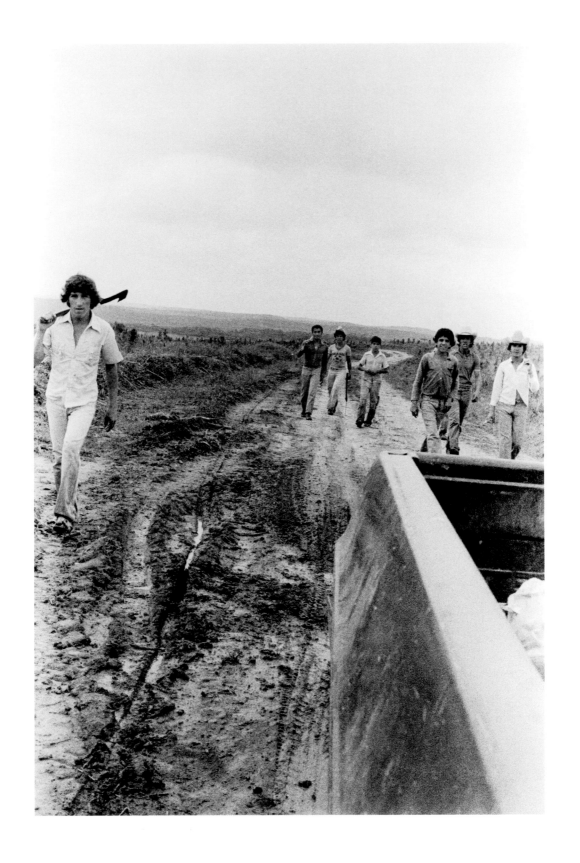

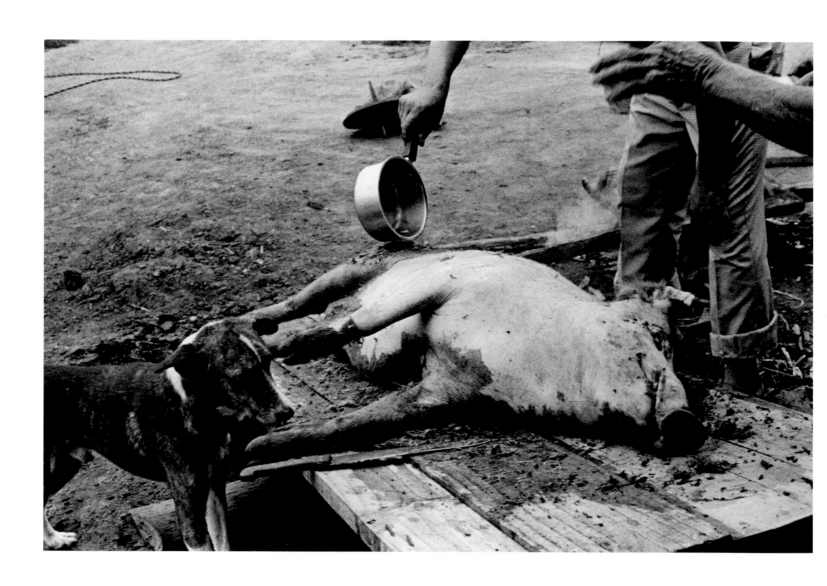

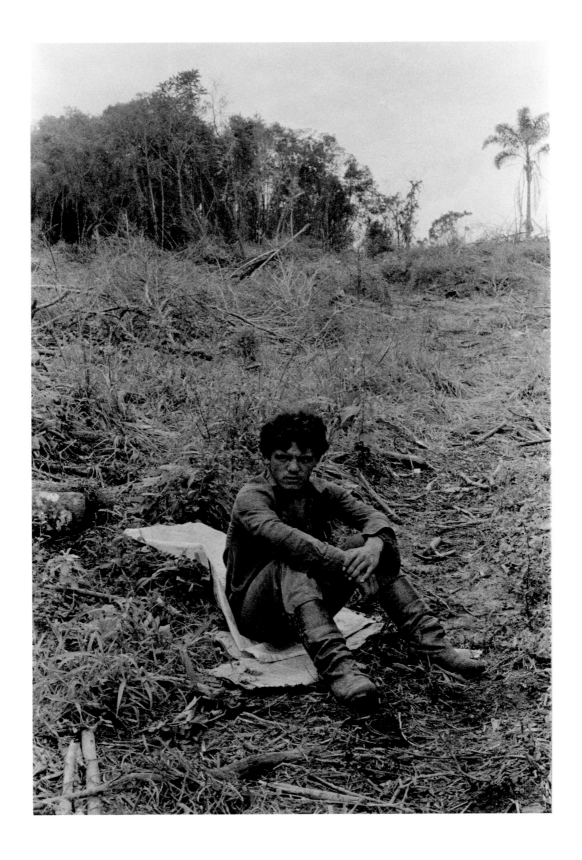

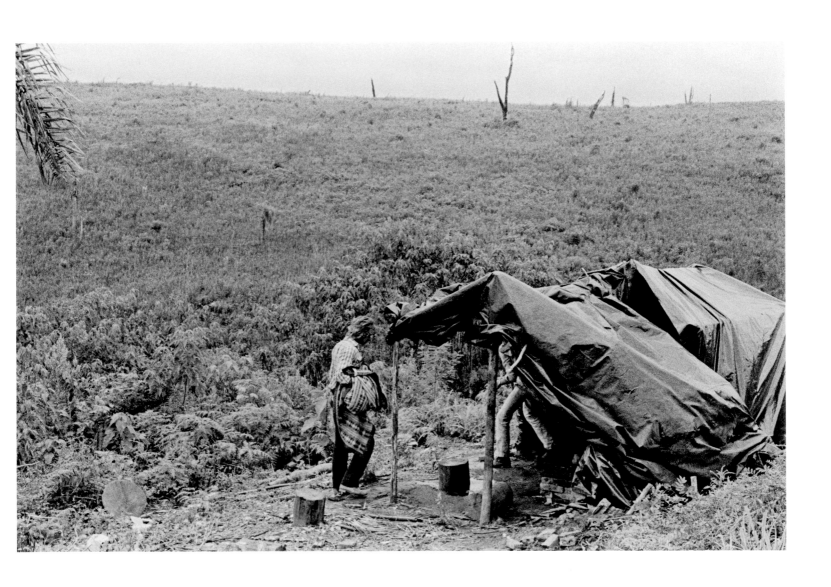

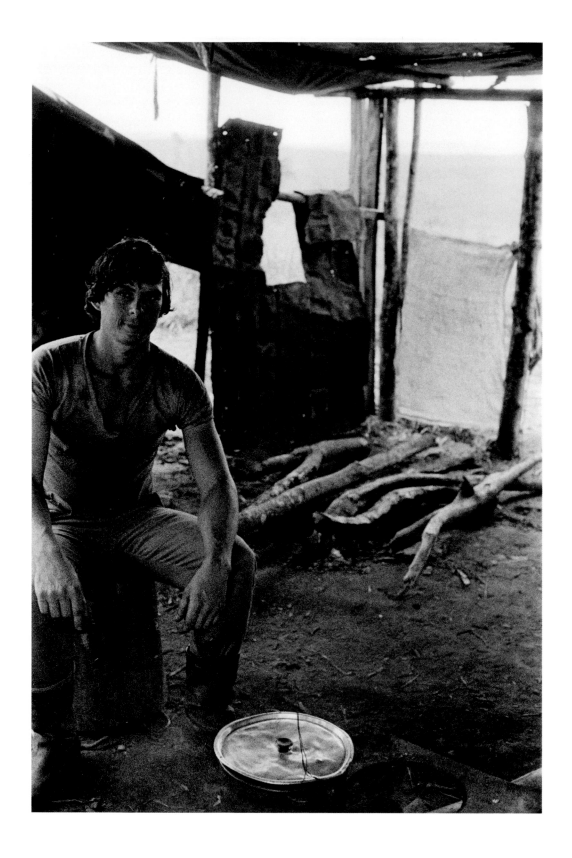

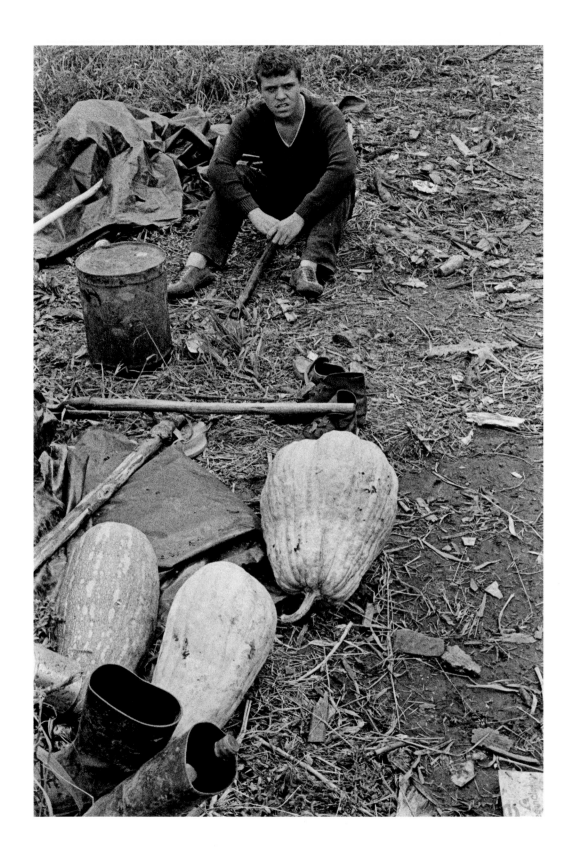

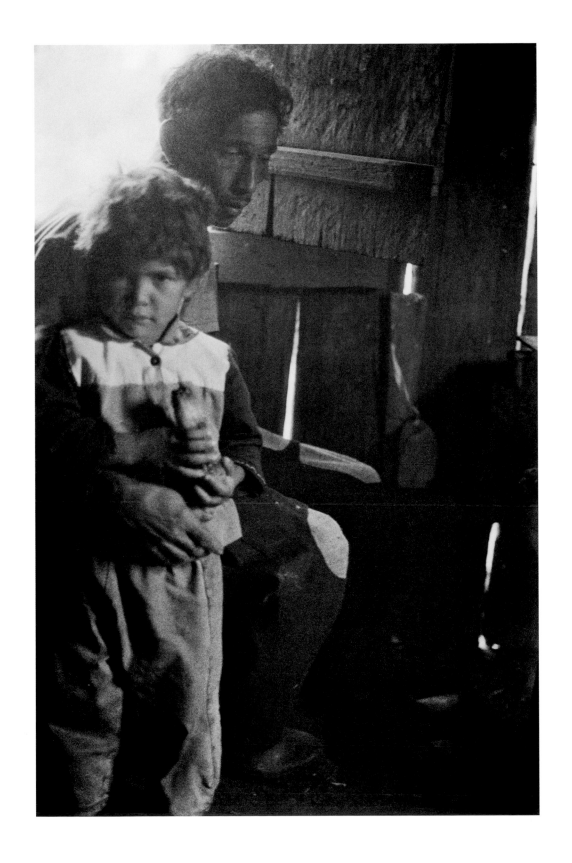

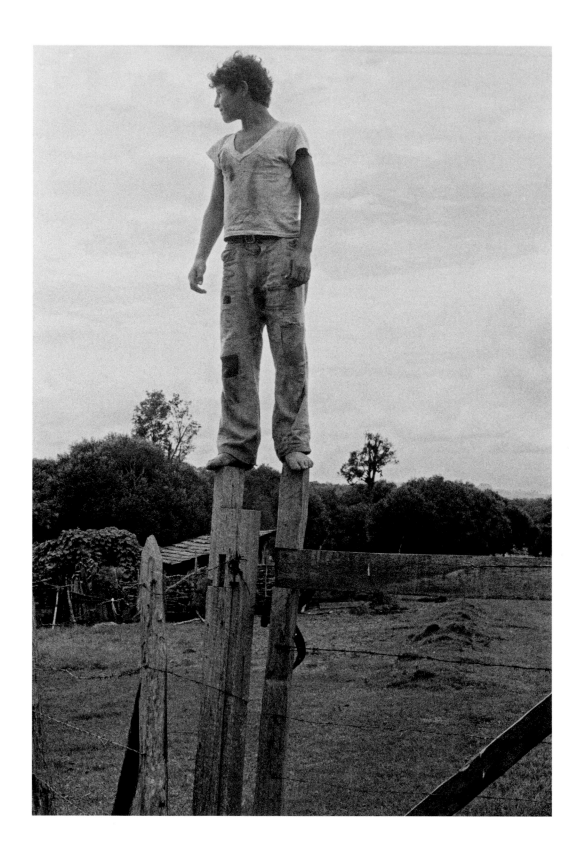

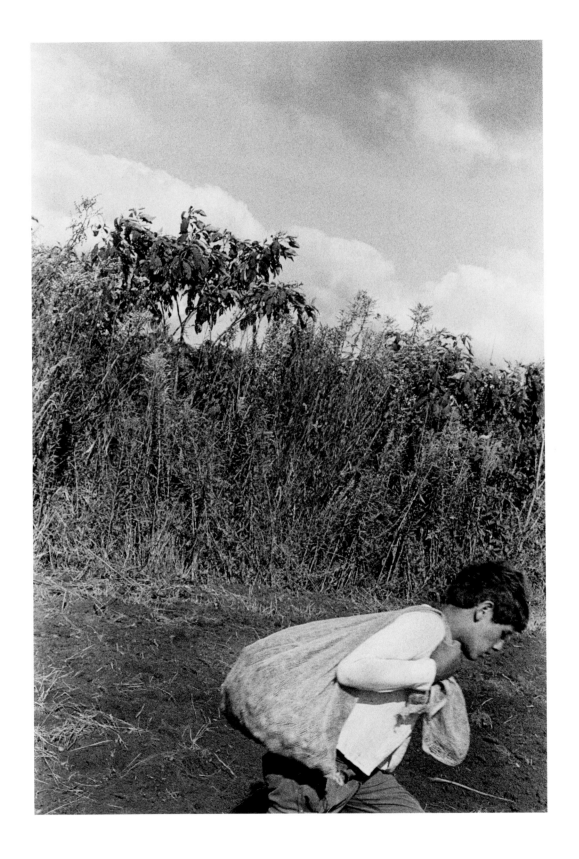

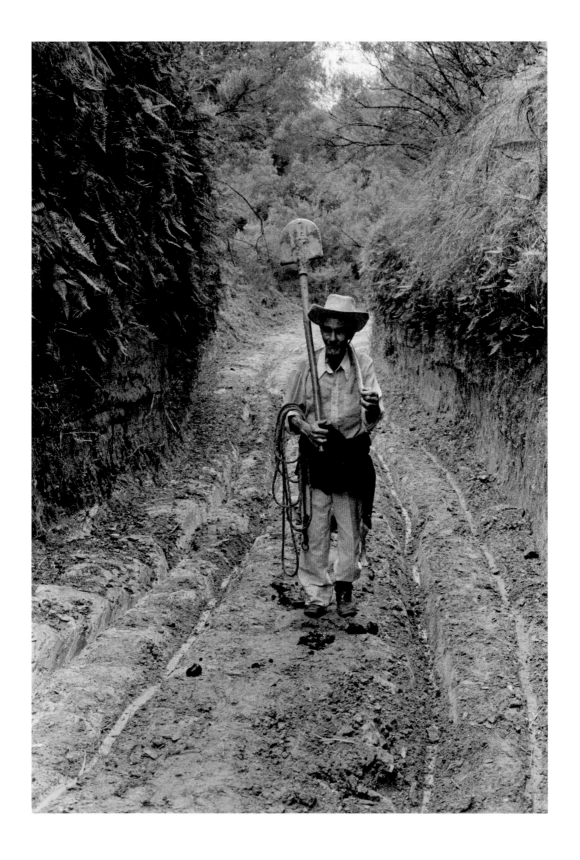

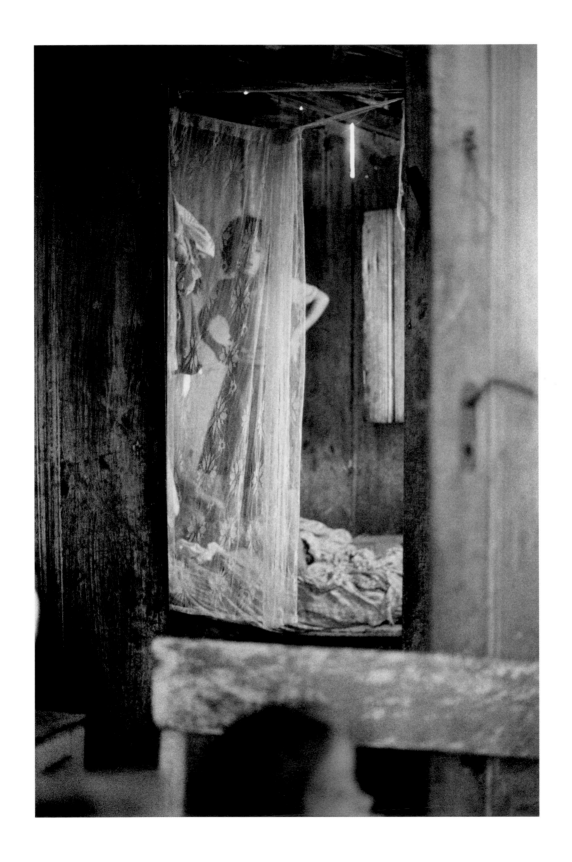

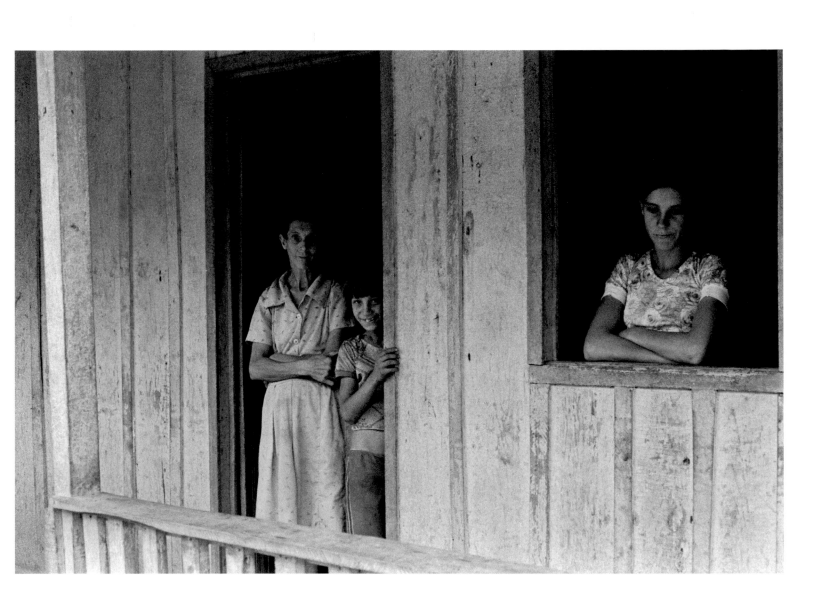

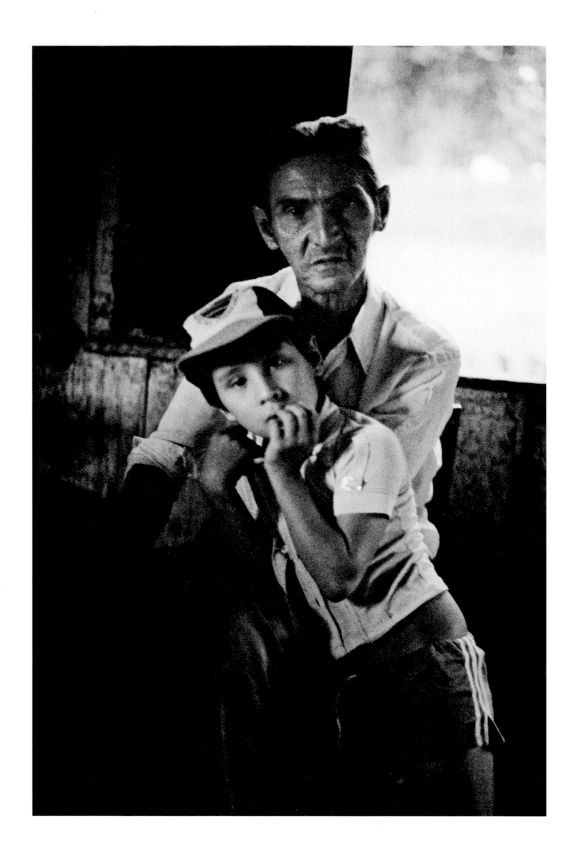

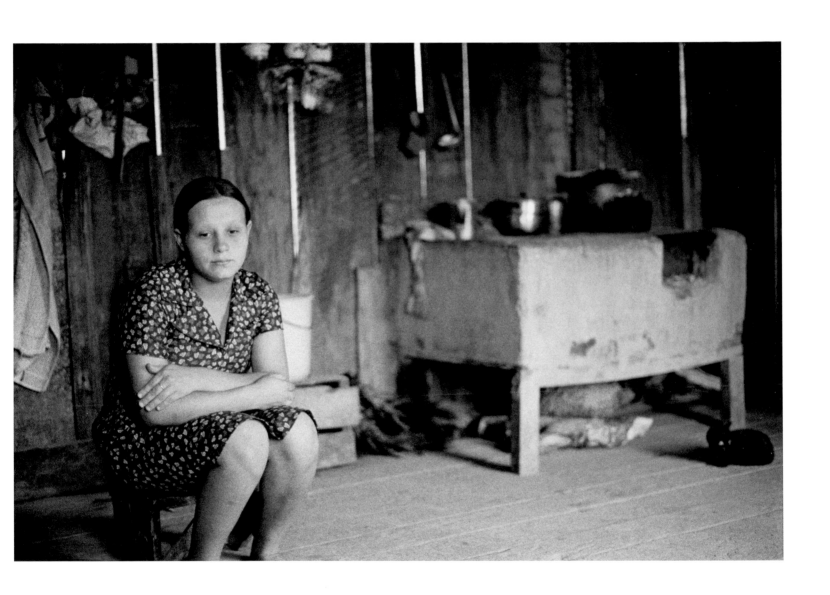

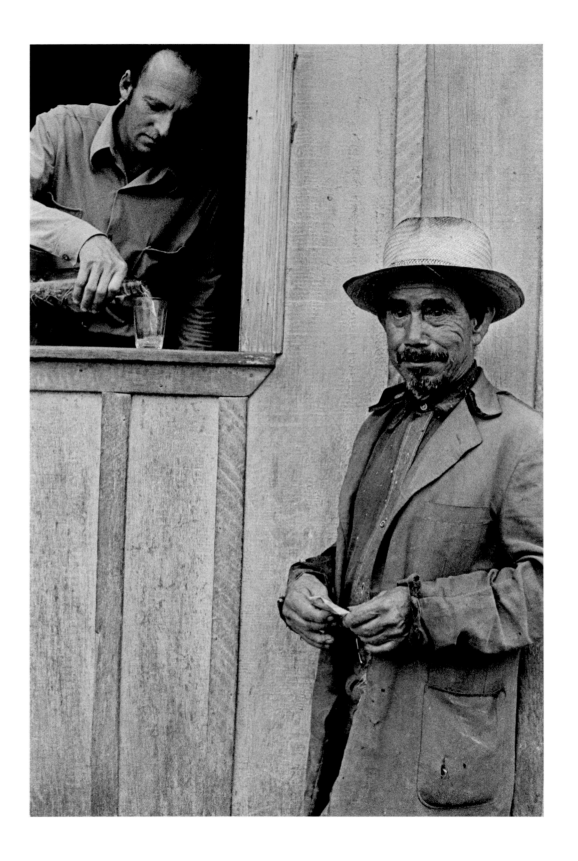

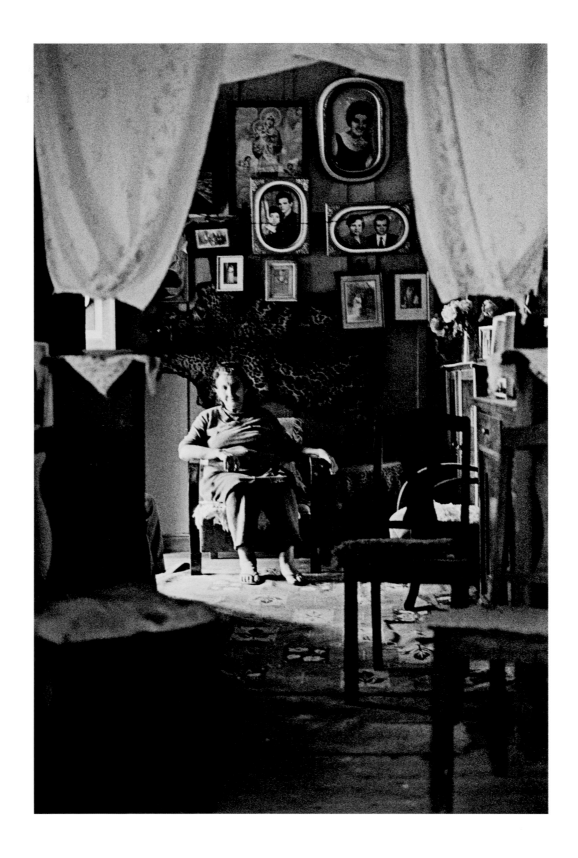

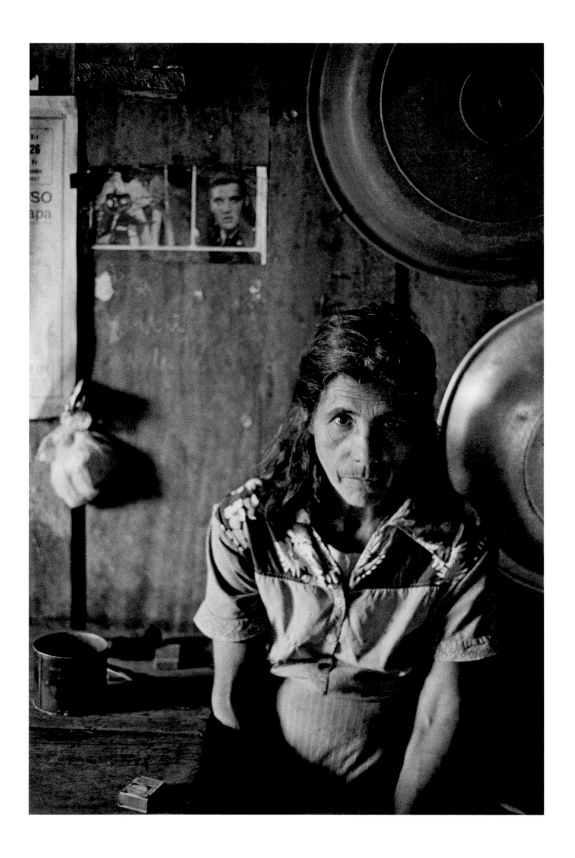

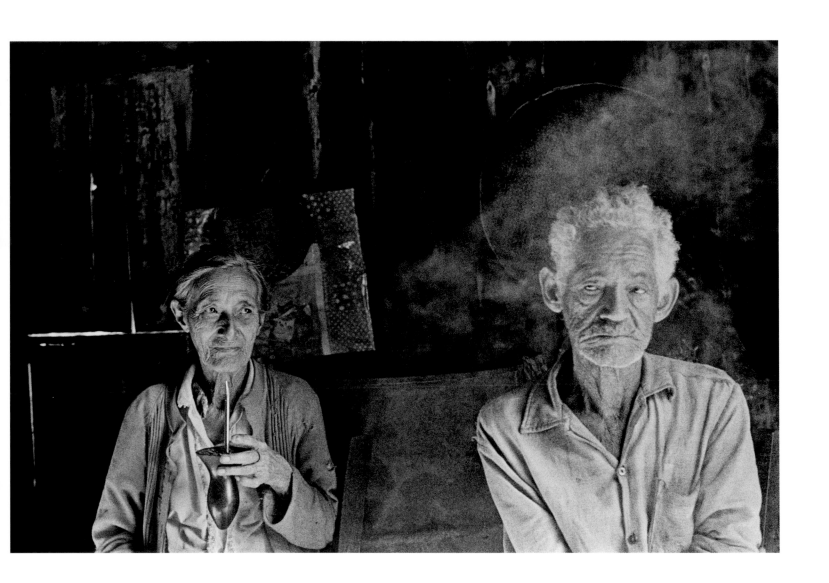

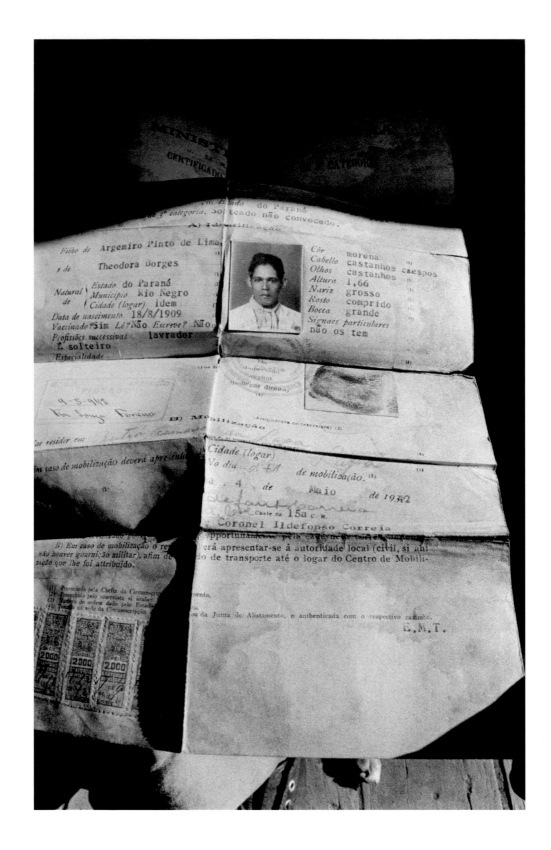

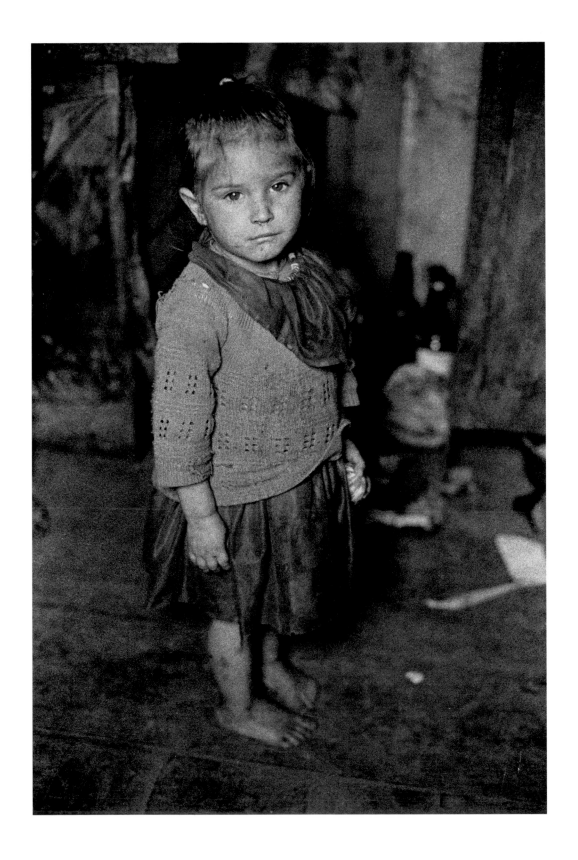

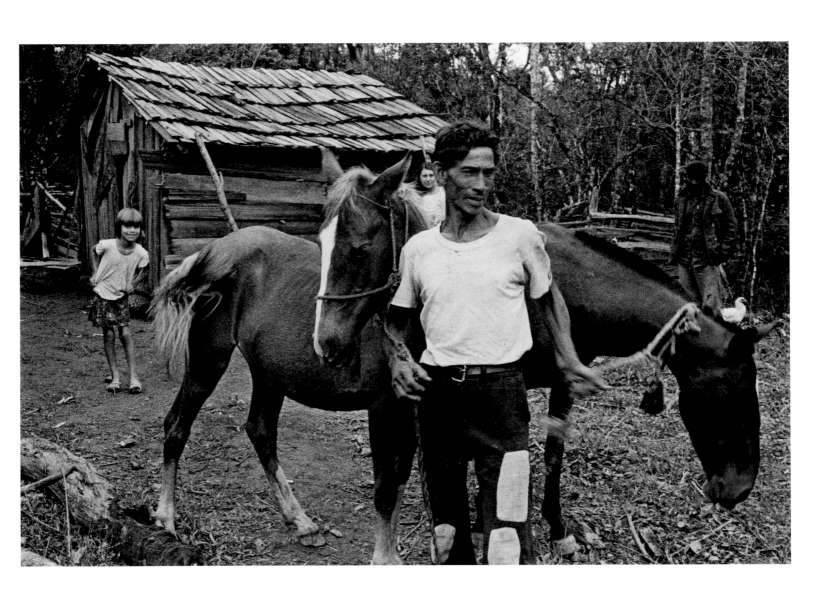

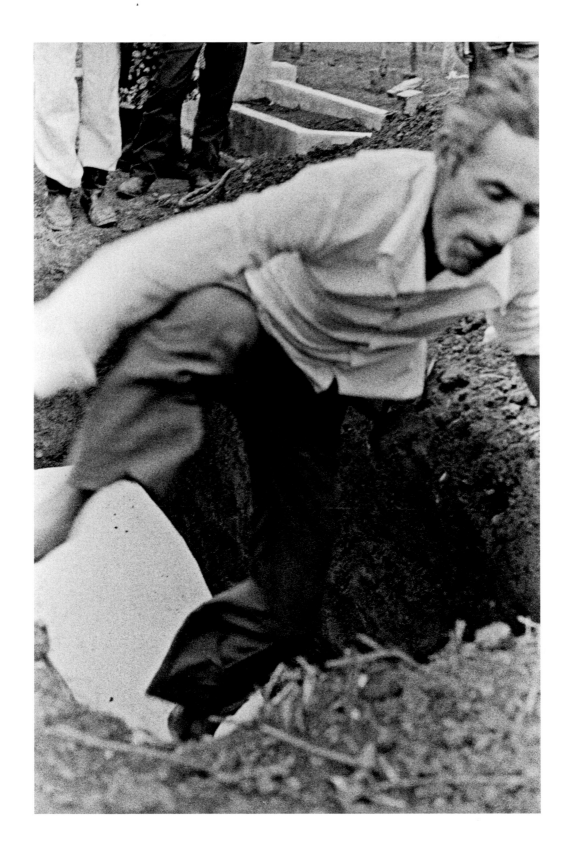

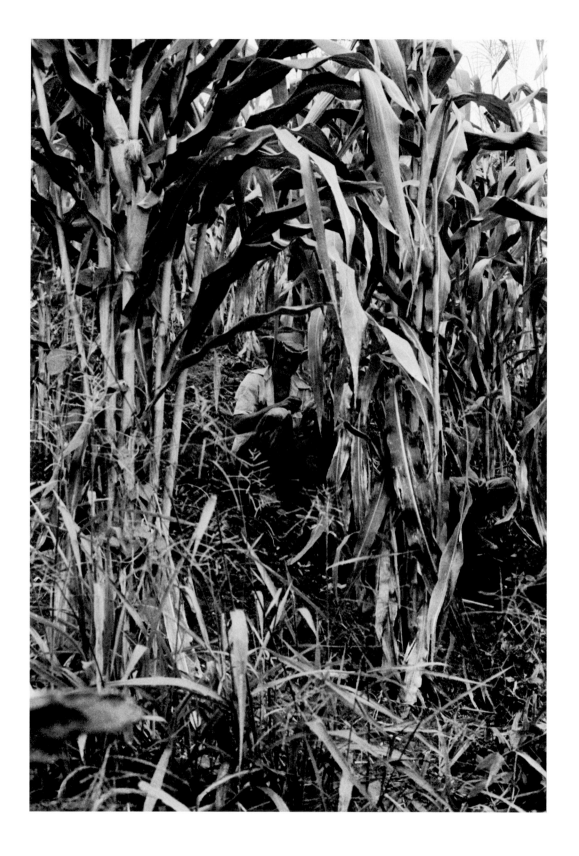

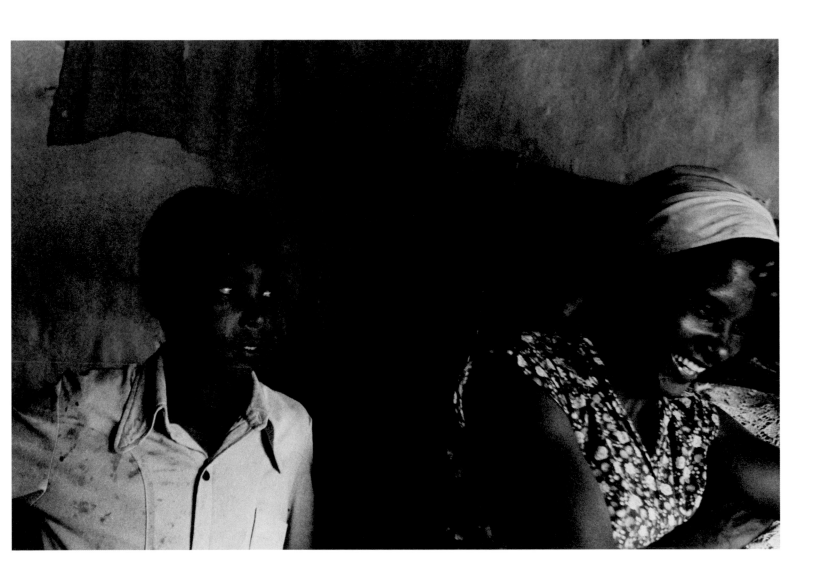

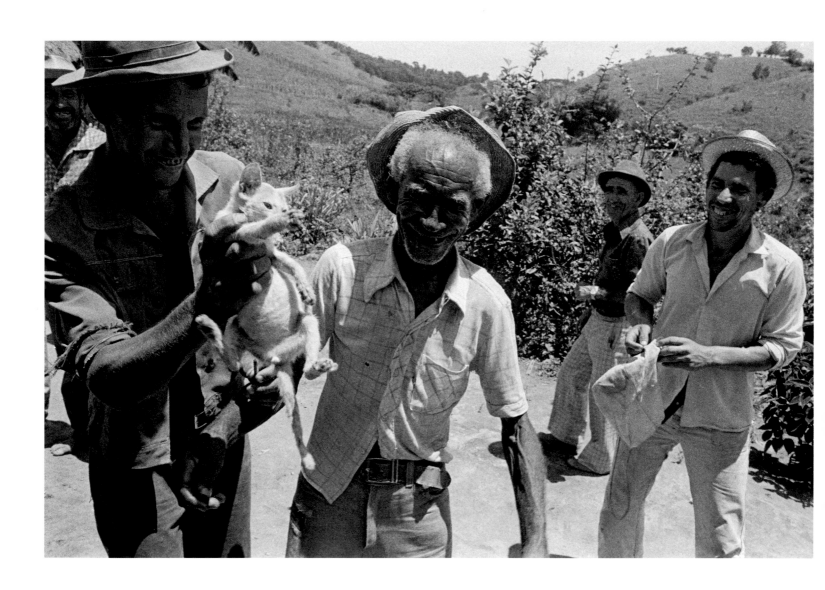

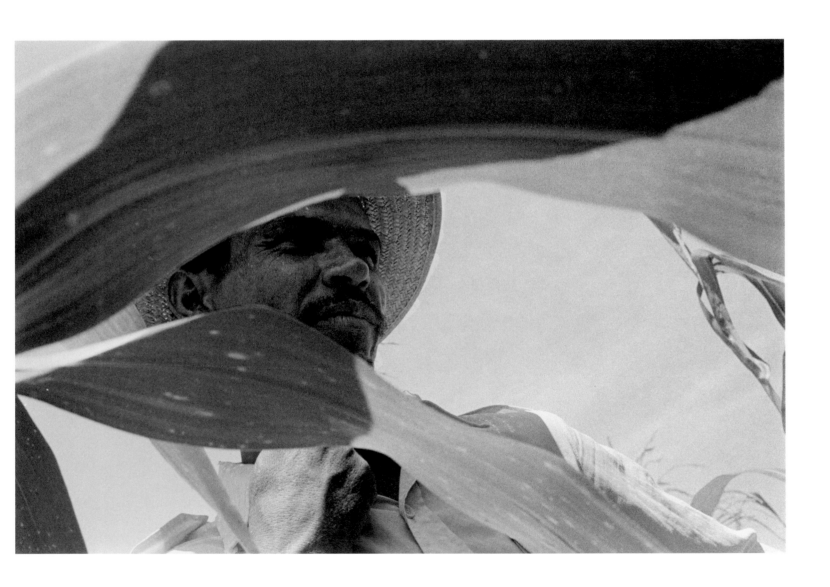

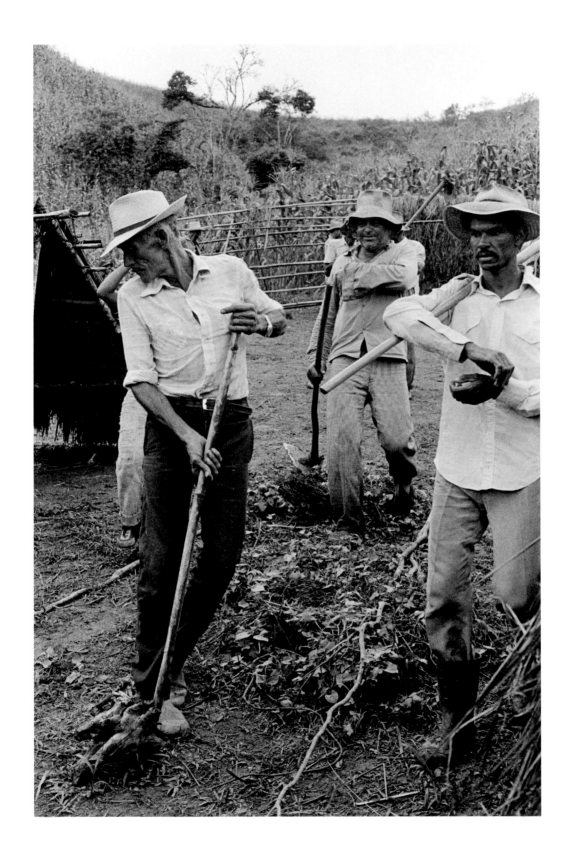

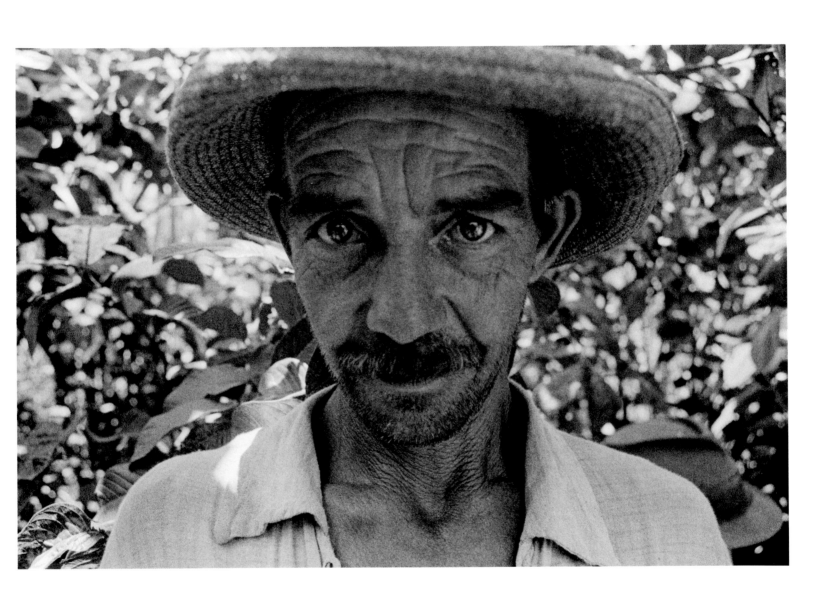

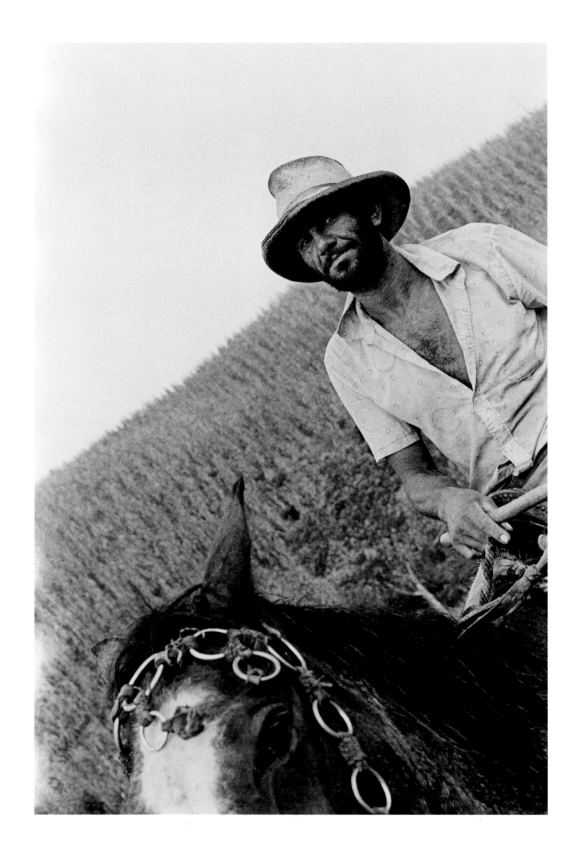

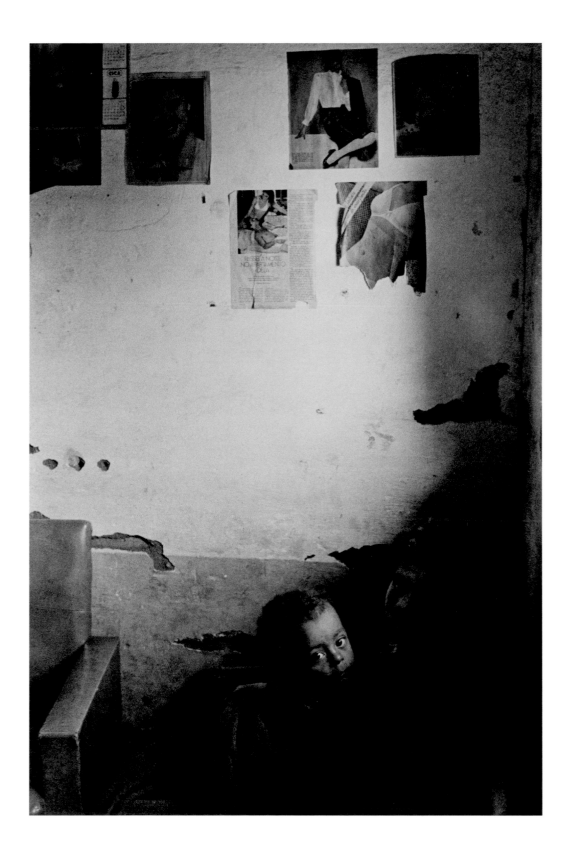

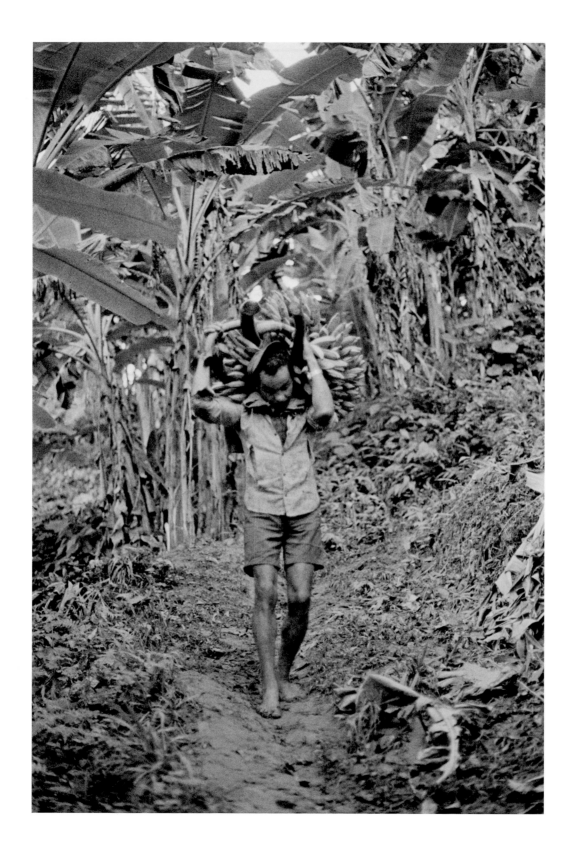

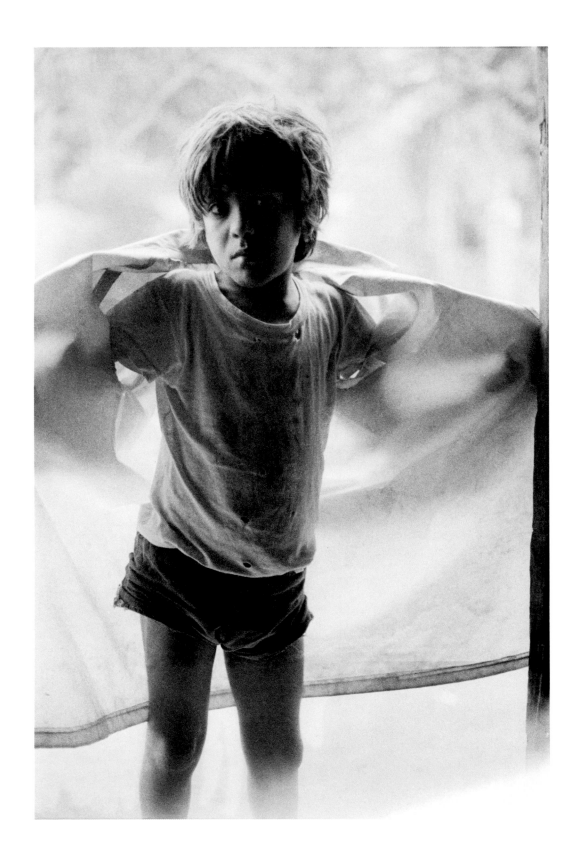

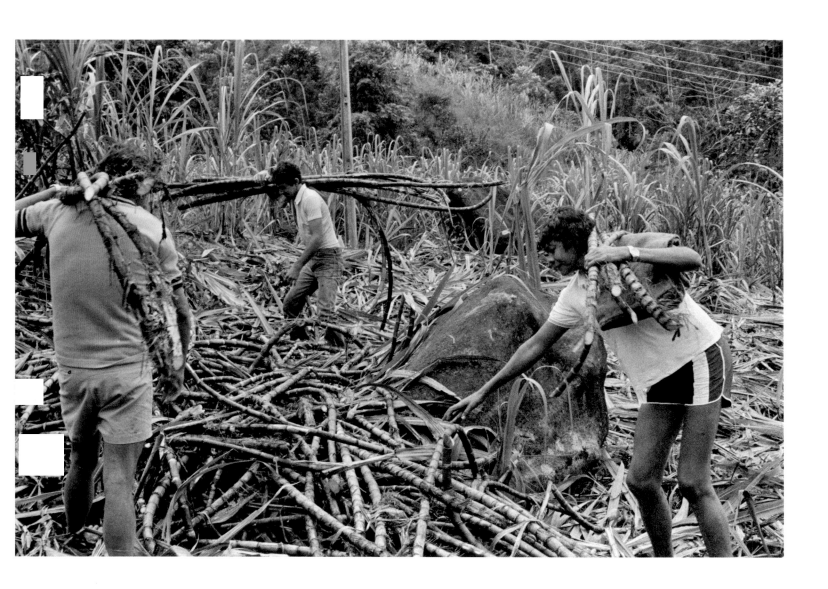

129

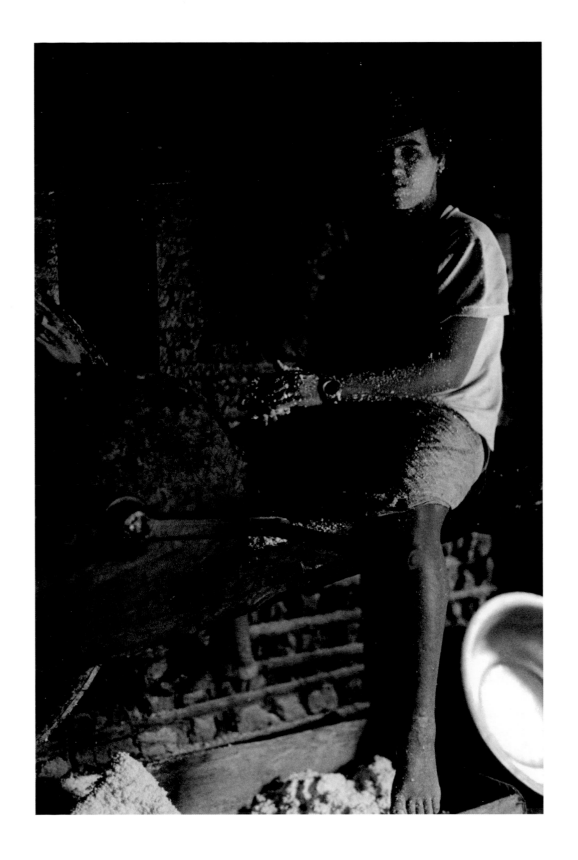

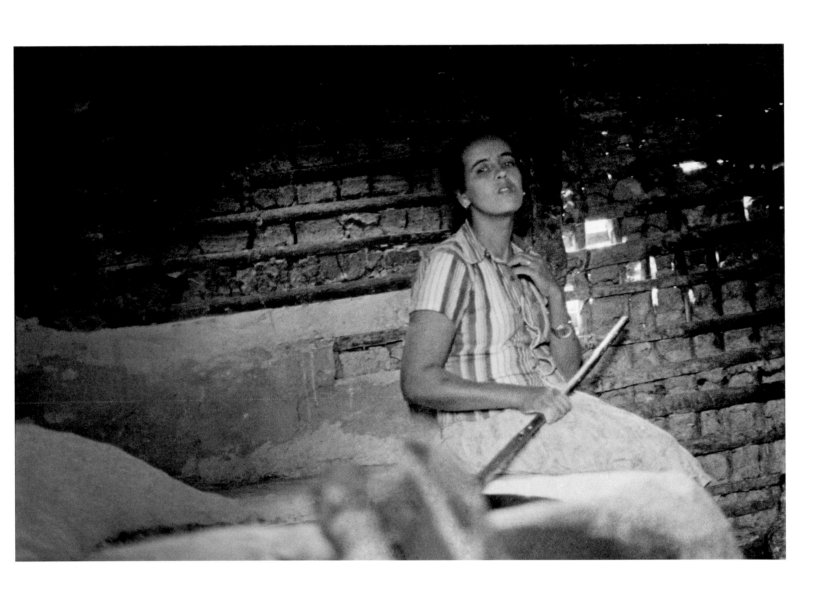

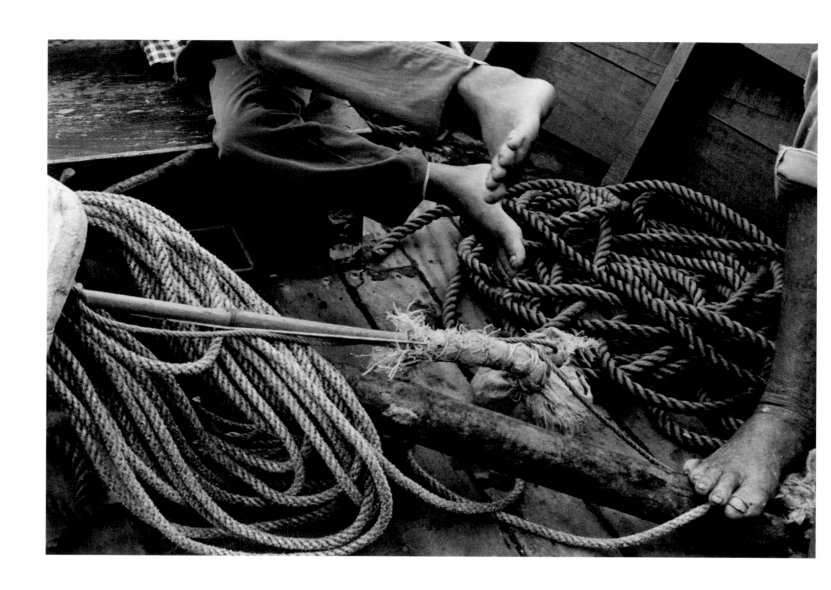

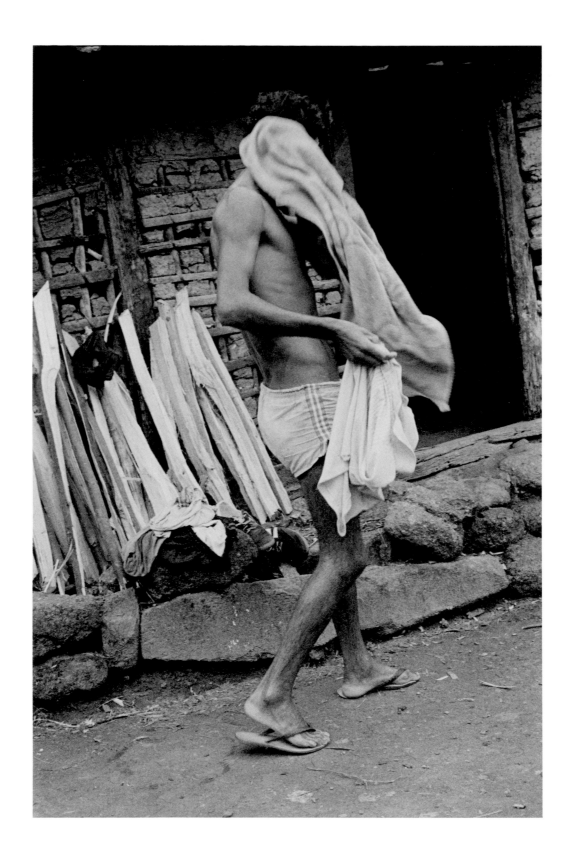

A VILLAGE IN
THE BACKLANDS
OF SOUTHERN
BRAZIL

Maria and José Antonio

They planted five acres of corn and beans. Fifty sacks of beans and thirty wagonloads of corn were harvested. They were expecting to harvest one hundred and fifty sacks of beans, but rain destroyed most of the crop. The income from this harvest was four hundred dollars (the equivalent of about six months of minimum wages).

Farming begins in August with the clearing of the land, which is ready for planting in late September after the frost has passed. During the *roçada*, when the ground is cleared, plowed, and seeded, Maria and José Antonio work from eight until six in the evening, but they spend an additional two hours traveling to and from the fields. Maria gets home at seven and starts the cooking fire, and in one hour, a supper of rice, beans, salad, and a piece of sausage will be ready. The leftovers are for lunch the following day. During the *roçada*, Maria does not rest on Sunday. She must wash clothes and clean the house.

For the planting, José Antonio bought on credit 130,000 cruzeiros (500 cruzeiros = USD 1.00) of seed and fertilizer. The soil has become poor here and can only continue to yield crops with high and costly maintenance. He was to have paid the bill in February, but due to the rains, there was not enough income to meet his debt. He was forced to sign another promissory note that increased the total bill to 150,000 cruzeiros. If he cannot pay by June, there will be yet another increase.

José Antonio is also in debt to the bank. With the bank loan, he bought a house that had previously been a barn, a horse, a manual rice thresher, and a new horse wagon. After the poor bean harvest, he sold his horse, the rice thresher, and the wagon to pay off some of the bank debt, but it is still outstanding at 180,000 cruzeiros. José Antonio rents land annually at 10,000 cruzeiros per acre, and he owes money to the landlord. He is hoping his mother, Ana, will give him two acres from her small property. He said he would be happy with half an acre, but Ana does not like his wife, so he will probably not get it.

Fifty thousand cruzeiros a year is spent on clothing, shoes, and travel; 10,000 on medicine; and 35,000 on union dues that should cover health insurance. (In reality, it does not. There are no buses to the town where they are registered, so instead they must go to another town and pay for the services there.) The insurance also covers the removal of teeth and it had covered the repair of tooth cavities, but no longer.

From March until May, there is not much farm work here. The crops have already been harvested, or will only again be harvested in June. The men from desperate families try to find jobs in construction or gardening in the city. If they cannot get jobs, they will then be forced to work on plantations. Some try to stay with their families by doing any odd job at any wage in the village. The only job available this time was with Edmundo, who had planted potatoes that are harvested during this period. The rains, however, destroyed most of the crop, so not many people were asked to pick. The average wage in this area is 300 cruzeiros (60 cents) for a day's labor.

Maria and José Antonio own twenty chickens, one pig, and three goats. Three chickens are killed each month. Maria does not like to kill them because "if you have a chicken, you will always have eggs." Maria had a few more chickens, but they caught a disease and died. She also had more goats, but two died shortly after they were castrated. "One of them could never stand up again after. He died of fear. The cut of the other one got infected with worms and he died of it."

Maria's mother-in-law had confessed that when you kill a cow, the rest of the cows go near the blood and cry. She said it is very sad.

Maria also washes clothes for the neighbors to help with the household economy. She charges 100 cruzeiros (20 cents) for one dozen pieces. Maria must walk twenty-two steps with a pail from the wash tank to the well. The pail, weighted down with a rock, is thrown in, then Maria pours this water into another pail (without a rock) to take it to the wash tank. She does this three more times to soap up the clothes and begin to rinse them. Four more pailfuls are needed to rinse them off. Maria has walked hundreds of steps with a heavy bucket of water and washed clothes for two hours to earn 20 cents.

Once when Maria was sick, she asked her sister-in-law, Fabiola, to help out and wash the clothes for her. Fabiola told Maria that for 100 cruzeiros she would rather be sleeping. Fabiola married Jefferson, a notorious gambler. He lost at cards a bank loan intended for farming; then he gambled away his mother Ana's beloved Araucária pine trees.

(He originally left her one tree, but in the end, he gambled that, too.) After that, he gambled one year's hospitality at his two-room shack and lost.

Fabiola and Jefferson (along with the gambler who won) were living on his mother's land. Jefferson beat Fabiola every time he found her alone with the guest he himself had invited. Whenever Jefferson left, she would have to keep a lookout to see when he would be coming back so she would have time to rush to a neighbor's house and wait for him to get home so that she then could come in.

Dorival, a brother-in-law of Jefferson, bought his mother-in-law Ana's land, but he would not pay for it until Jefferson and his family, along with the gambler, moved out. Jefferson's solution was to move into his mother's house. Dorival still would not pay. Now Jefferson lives down the road. He borrowed money from the Bank of Brazil to farm some land that his mother still owns. The rains destroyed most of his bean and potato crop. If he had planted corn, it would have been better. But it is not something that is easy to know. Now he must pay back the loan. In a few days, he will be charged daily interest rates, and his mother will lose thirteen acres. Jefferson has been missing for ten days.

Teodoro, a friend of Jefferson, borrowed 400,000 cruzeiros from the bank. Jefferson, along with Norberto, who was the guarantor of the loan, spent it on taxi rides and gambling. Then Teodoro could not pay the bank, and Norberto was obliged to do so. He kept threatening to kill Teodoro if he did not pay at least 20,000. Teodoro was forced to borrow money from Dorival with interest rate and monetary correction for the inflation rate.

Ana does not like Maria, José Antonio's wife, because she is dark (about as dark as Ana's husband). Ana calls her "Aquela Negra" (that Black woman). In Ana's sitting room, a framed photo hangs. It is of a Black woman, her husband's mother, while her husband himself was a *Bugre*, of indigenous descent. Ana's first mention to me of Maria was "the woman that José Antonio married. She's Black, but she washes clothes really clean." Maria is indigenous, but Ana would not dare insult her that much by referring to it.

Maria said that the wife of the farm specialist was dark but very nice and had taught them about compost.

When José Antonio was sixteen, he kidnapped Maria, who was fourteen. (It is the local custom and the most common way for a young woman to marry. If the couple succeeds in staying away for one night

and the young man is not found and killed, then it is assumed the young woman is no longer a virgin and must marry the man.) He took Maria to his mother's house, proudly displayed his woman, and then asked his mother what he should do with her. Ana said since he stole her, he would now have to marry her. They lived with his mother for almost a year. Ana would encourage José Antonio to go to local parties so that he could enjoy his youth, but Maria would have to stay home to keep Ana company. After ten months of this, Maria left José Antonio. She agreed to come back only if José Antonio would take her to parties and build them a house. In two days, he built a little house for them.

Ana adopted José Antonio when his mother died. José Antonio's father was mentally unbalanced. One day he accidently set fire to his nephew's barn. As a joke, the nephew said that he was going to get the police after him. Every time a car would pass through the village, José Antonio's father thought it was the police and would run into the woods to hide. One day he ran in and did not come back. Pieces of his body were found eight months later.

José Antonio is sure there is a big pot of gold waiting for him. In the woods, he pointed out lots of places where he has been digging. Since he has not had much luck, he went to consult a spiritualist, who told him she is unwilling to tell him where the gold is unless he takes her along and gives her half of the treasure. The last time she helped someone, she said, the spirits got angry and chased them away from the treasure. However, the following day, the man returned without the spiritualist and took the treasure all for himself. He now owns a car, a truck, and a grocery store. José Antonio assured her that he would not do the same. Maria suggested that it would be interesting to photograph, and if the spirits attacked, one could always explain to them that one was just the photographer. And anyway, maybe the flash would scare them away, Maria added.

RECADO

Esse é Antônio.

Ele vive num sítio que fica um pouco distante da cidade.

No sítio, Antônio tem um pedaço de terra, onde ele colhe muita fruta, planta muita verdura e ainda cria galinhas.

As frutas, as verduras, as galinhas e os ovos dão para o sustento da família de Antônio e ainda sobra muita coisa!

O que Antônio faz com o que sobra? Ele vende na cidade.

(Translation: "This is Antonio. He lives on a farm that is somewhat distant from the city. On his piece of land, he harvests many fruits, plants many vegetables, and even raises chickens. The fruits, the vegetables, the chickens, and the eggs provide sustenance for Antonio's family and there is much left over. And what does he do with what is left over? He sells it in the city." From a literacy book for adults published by the Ministry of Education and Culture, 1977.)

Bolinhos de Arroz
(Rice Cakes)

1 plate cooked rice
1 cup flour
1 egg
1 tablespoon salt
baking powder

Mix ingredients well and then
roll into balls and fry.

The Local Despot

Dorival owns a grocery store in the village. For lunch at his house, there is rice, beans, corn or manioc flour, sausage, pork or beef, potatoes, fried manioc, bread, sweet potatoes, corn, salad, and pumpkin candy for dessert. He makes his profit on the interest rates he charges the farmers who must take credit with him. From March through May, while they wait for the harvest, most farmers must buy groceries on credit. There's only one other grocery store in the village, and it is owned by Gustavo. His prices are lower, but he cannot afford to give credit. If Dorival finds out that a customer who has credit with him buys at the cheaper grocery store, he threatens to suspend credit and call in the bill before the harvest. He will also loudly admonish them publicly in his store against shopping at Gustavo's store.

Dorival's eldest son is studying in town to enter the university. He spends monthly 45,000 cruzeiros, and his school fee is 9,000. He did the same course last year, but out of twenty-five history questions, he got three right (they say because he had cheated). Out of twenty-five English questions, he got one right. His parents want him to be a dentist. We have never seen each other except perhaps when we were children. We were talking on the veranda. I was sitting and he was leaning against the fence. He would look at me from head to crotch and then squeeze his penis. He asked me about my love life, saying he thought I had none, the way I only talked about school and work. He then said that he had had many women, but only one that he liked. They were together for six months, but they both failed the exams because they did not study. He broke up with his girlfriend because she refused to have sex with him. He tried to convince her that otherwise he would be knowing her only superficially. When he was seven, he would be drinking a soda and his father would grab it away and give him beer. Dorival said, "I take only men by my side. If you are a man, you will drink like me."

José Antonio in 1982 paid Dorival 40,000 cruzeiros (more than one month's minimum wage) in interest for groceries he had to purchase while he worked odd jobs.

During the harvest, Dorival has been known to send his hired hands to harvest the lands of customers he thinks will delay in paying

him. He left one family in the village without beans for the following season, so they had to buy beans from him—on credit, of course. Dorival can spend an entire afternoon removing fly larva buried under the skin of the dogs that sleep by the log in front of the grocery store, or he will spend a fortune at auctions buying wild animals to set them free in the forest, but he cheats the illiterate farmers out of their change. Dorival does not talk much; he never explains or excuses anything he does. No one is hated and feared so much in this village as Dorival, not even the timber developers.

He lets groceries mold before lowering the price. At the end of the day, he gives any extra milk to his pigs. He also buys crops from the farmers who are indebted to him for less than the going rate. For example, he pays 1,000 cruzeiros less per sack of beans than the official minimum price.

When Dorival married Marlice, he moved into her mother Ana's house. While he raised his pigs on Ana's land and butchered them to sell at his grocery store, he would kill Ana's pigs for his family's meals. He cut up a lot of her majestic Araucária pine trees to build his house and grocery store. He has bought up almost all of Ana's land to raise cattle. He now controls a piece of the river that goes behind her house and she can no longer wash her clothes on that section of the river and must go farther down and cross a dangerously rickety bridge with a heavy bucket to do so. He has also bought the land on which Maria's house stands for pasture for his cattle. He has said to them that they can still live on it, but they cannot raise chickens, goats, pigs, or horses. So now Maria and José Antonio must sell all their livestock at a time when all the neighbors are heavily indebted and the price therefore will be low. With no livestock and no possibility to afford to buy meat, they plan to move to town and look for work there. As the economy is in a severe crisis and unemployment high, some families in town have begun to move back to the countryside, hoping that by farming they will at least be able to eat. They arrive with nothing and their first crops have failed. Since everybody owes money to the bank, Maria and José Antonio have only been able to sell the goat shed this year, and next year, they will try to sell the house. They will settle in the local town since it is easier to find a job there if you are not educated than in the capital city. He would work in a factory and she as a maid.

Carlos, the brother of Ana's husband, has land that is unfortunately located across the road from Dorival's new pastures and he has been

informed by Dorival that his livestock will not be tolerated. Carlos, who is elderly, must now also sell his chickens, pigs, cows, horses, and house. He and his family will then have to move into town.

Dorival's daughter is the teacher at the local school. She reads from a textbook that says, "The obligation of a storeowner is to profit in commerce. The obligation of the police is to maintain order and punish the disorderly."

Grocery Store Prices
(in cruzeiros)

Grocery Item	Gustavo	Dorival
White flour	400	500
Corn flour	100	150
Sugar	800	1,000
Bacon	350	400
Salt	40	60
Matches	80	100
Rice	1,000	1,400
Oil	250	300
Margarine	120	150
Soap	90	120
Macaroni	200	300
Yeast	100	150

Pinhão com Carne
(Pine Nuts with Meat)

Cook *pinhão** with dried meat, pepper, and coconut and then mash.

**Pinhão* are the large pine nuts that grow on the native pine trees, Araucária.

Hail Mary

Hail Mary, while the rains don't stop pouring.
Hail Mary, while the beans, rice and corn drown.
Hail Mary, while the whooping cough kids—
Hail Mary, cough.
Hail Mary, while you sell the horses,
Hail Mary, sell the ducks, chickens, goats,
Hail Mary, sell the rice thresher, sell the stove.
Hail Mary, while your field-bent husband plows
Hail Mary, plows with no horses.
Hail Mary, while the bank forecloses your land.
Hail Mary, while you pray as the rain pours.
Hail Mary, as you pray for the rain to stop.
Hail Mary, as the rain doesn't stop.
Hail Mary, as the rain doesn't stop.
Hail Mary, what do you do now?

Doce de Banana
(Banana Dessert)

Cook banana with sugar.

The Timber Company

Since José Antonio was not going to buy groceries on credit because the interest rates were too high, he went to work as a day laborer at a timber company about two hours away from the village. A multinational company owns five thousand acres there. The entire area had been virgin forest, a worker there explained. The company is systematically burning it all down, leaving extant the strip near the river, which will protect the banks from erosion. Where once native Araucária pine trees grew, North American pines and Australian eucalyptus trees have been planted. This is called "reforestation." Timber developers are eligible to receive monies from the government for the replanting of trees in "deforested" areas.

José Antonio likes to work for the timber companies because "they're clean." He means there is no undergrowth to hide snakes. In these man-made forests of non-native pines and eucalyptus, there are not even birds. There's no food for them. Locally they are known as the "Forests of Silence." The acid from these trees kills all other native vegetation.

The men on this plantation are paid by the amount of land they clear. This is a smart move by the company's agents since they do not have to pay the men for days when they cannot work because of the rains. José Antonio will test it out for a week and see if he gets paid; if so, then he will continue. He is already wary because the company is going to give the men a wage based on the old official minimum wage. The men will get one minimum wage for clearing an acre, which the overseer says takes fifteen to twenty days. The men say it takes thirty days. They work ten-hour days. They are responsible for their own meals and for moving camp every four days.

José Antonio was also worried about the overseer keeping his workbook, which is kept by the employer until the employee leaves his job. The amount of pension to be received upon retirement is based on the days of employment registered in this book. It is common practice for employers not to return workbooks as a threat to keep employees working for low wages or no wages at all. The men can thus become easily enslaved. José Antonio was worried about this and had asked me to come along and tell the overseer that I was a journalist.

He asked me to take many photographs of all the men working there so that if they were made into slaves, I would have proof that they existed. José Antonio said to the overseer that he had forgotten his workbook and would bring it with him next time.

For working one week, José Antonio took one pair of work pants, one pair of dress pants, a shirt, a hat, a suit coat, socks and sandals, corn flour, rice, coffee, sugar, salt, bread, tobacco, a spoon and knife, and one candle. He cooked his food in old tin cans.

The company provides the men with plastic for makeshift tents. The men usually build a tent against the side of a hill to get some shelter from the wind, but when it has been raining hard, the water coming down the side of the hill pours into their tents. After the first rain, the men were forced to take time out to make bed stands.

The only transport to their villages is by the company truck, which cannot make it up the hills when it rains.

The first thing José Antonio did when he got back from working at the timber company was to go to the bar and get drunk and gamble. Maria was very angry, but he had won at cards, he explained. As it turned out, he won a dozen bottles of beer, which only made her angrier. Then Maria started complaining about the jobs he got and the wages he was getting. She asked him why he had not gone to work at the apple farm where they were paying more money. José Antonio said that the land there was much more difficult to clear and so you would get less money in the end.

Bugres

Maria said near the fields she farms, where there is still some forest, she sometimes hears strange noises that are the spirits of the Indians walking about. She said that over the years there has been less noise because game has not been plentiful, and the spirits, having no food to live on, have moved on.

Maria had asked me what I thought about Indians. Much later, she told me of a conversation she had with Ana, her mother-in-law, who tried to insult her by reminding Maria that her grandfather was *Bugre-puro*. (Native peoples are usually called *Bugres* in this region. The word means "monsters," as in the "Boogey Man." The word also serves to de-tribalize indigenous peoples by removing specific identities. Those now called *Bugres* are originally from the Kaingang tribe.) Maria said, "I told her it did not matter because you had said they are good people. Ana got very quiet after that."

Maria's father talked about the *Bugres* of Barra Preto de São Bento at the turn of the century. "Machado owned a string of mules. His wife was in the house, cooking, and she screamed, 'Look, there's a whole bunch of naked people coming!' Machado said they were *Bugres*. The chief was beating his chest and Machado shot him. The *Bugres* got angry and tried to kill the farmer, but he escaped with his wife. The *Bugres* killed the mules and put the cat in a boiling pot of beans. They then picked up their chief, decorated him with feathers, and buried him. Machado got his neighbors to help him find the *Bugres*. One of them knew how the *Bugres* set up traps along the path to their villages to keep intruders out. When the men got to the village, the *Bugres* were asleep. The men first cut the strings on their bows, which lay outside the huts. They killed them all—and yes, the women and children, too."

Maria's sister said that their great-grandfather took a *Bugre* woman and had to tame her because she was like a wild dog.

"She looks like a *Bugre*" was the reaction of Maria's cousin upon seeing a photograph of their great-grandmother. Maria said, "That's not true. José Antonio's mother says that, but it's not true."

Otávio took Maria and me to visit Miguel, the *Bugre* who lives in a nearby village, an hour's ride by horse and wagon. Miguel was not home when we arrived. Otávio set out to find him by following his

tracks. An hour later, he came back with Miguel, who had been out hunting. Otávio said at first Miguel had not been willing to come back to his house and meet with me because he was too embarrassed by his poverty.

A few days earlier, when I was at Dorival's bar, I had met Miguel and he was very drunk. The men there asked me to take a photo of the *Bugre* and mail it to them so they could later taunt Miguel about how ugly he is. I did, but only because he is handsome. Once I had seen Miguel sleeping outside the bar steps with his groceries—some sausage. During the night, Dorival's pigs ate up his food.

Miguel came down the hill behind Otávio. He was nervous. Right away he gave us some tangerines as a present. Then he led us down to his home, which is at the edge of a little strip of virgin forest. It was a small one-room shack. He was too embarrassed to invite us in. Through the door, I could see his breakfast leftovers of cornmeal mush still sitting in a tin can on a makeshift grill. Miguel farms three-quarters of an acre. Half of his corn and bean crop are given over as rent for the land. He was also trying to raise squash, but the plants got infested with insects and died. Out in front of his shack were some feathers; they were from wild chickens, the *jacu* and *oruru*, that he catches with a homemade trap, the *arapu*. Out in back and toward the side of the shack passes a river, the banks of which are steep and you have to hold on to trees and their roots to make it down and not slip in the mud. Miguel said he always likes living in places like this because they were quieter and there were more birds that sang. Maria, with her long coarse dark hair, almond eyes, and copper skin, asked Miguel, the *Bugre*, if he ever saw Indians here. No, he never had seen one. His best childhood friend had been an older brother of José Antonio, who was called *Rouge* (Red Face) for his coppery skin. I left saying he lived in a beautiful place. He already knew that, he said. Miguel is the hardest drinker at the bar, Otávio said, but he is also the hardest worker and never buys on credit.

Maricota's house is small and carefully decorated inside and out with pictures of saints, plants in gourds, and flowers made from cut metal and plastic. She was standing outside combing her granddaughter's hair.

Maricota requested a special photo of herself—inside her house with no kerchief on. She did not want foreigners to think she had white hair just because she was an old lady. As she arranged her hair, she proudly said, "I'm ninety-eight and I don't have one white hair. It's all

black." The young men in the village learn to dance from Maricota. When she goes to a dance, she is never left without a partner. "The people here think I'm Italian because of my black hair and fair skin, but I am *Bugre*, *Bugre-pura*. That's why I don't have white hair."

Maricota's son had raped a fourteen-year-old girl and also a married woman. He has been in jail for two years and will be there for some time more. His wife has three children. She must now farm by herself, take in laundry, and count on her mother-in-law's meager pension to help take care of the family. The children are staying with different relatives. Maricota's granddaughter said she wanted to grow up quick so that I could take her away from there.

Ana and I were going through her photo album. Every time there is someone in the family who is blond and fair, she says how pretty or handsome they are. When it is someone who looks indigenous or Black she says how ugly they are except for her husband. He too was of indigenous (and African) descent.

An Old Man

An old man sits out in the sun playing with pebbles and grass. He cannot walk. He just sits. He is retired and is taken care of by Diogo, one of the wealthier farmers in the area, who also fixes cars and tractors and fills butane lanterns.

 Diogo is given all the old man's pension. It is said that no one in Diogo's house is allowed to eat until he gets home. All the cabinets are locked and he is the only one with the keys. He even had the pots and pans locked up. The old man is fed a small plate of food and has to satisfy himself with that. One time Julio was there and saw the old man staring at the bean pot with big eyes. Diogo treated us very well; he showed us around his place and gave us coffee and cake.

Julio

While I was at Maria's house, I caught a cold. I asked her uncle, Julio, to get me some toilet paper and cough drops at the grocery store. Maria said I should write it down because her uncle had never bought any of these things and would not be able remember what they were called.

Julio lives across the road from Ana. After she became a widow, Julio's older brother became her lover, it is said. He is still very handsome and a great dancer.

Julio was born in 1923; back then, his family had thirty acres of land. Today he has half an acre, one bed, one bench, one new pair of underwear, one new pair of pants, one new shirt, work clothes, two cooking pots, a kettle, one spoon, one knife, one plate, and one cup.

Ana said that only recently has Julio begun to act like a human. "He resembles more the Moreira side of the family. They are *Bugres*. His older brother is lighter. He is nicer. They are no good. They lost all their land." I reminded Ana that his family was similar to her own, which had also lost all their land.

Julio farms on rented land, so some of his crop goes to the owner. He must also borrow a horse and cart from a neighbor for the harvest and in return gives five *gilas* (pumpkins), which are good to make candy.

Julio's one-room house is close to the road. Schoolchildren on their way home stop to decorate Julio's house with tree branches and flowers. Gypsies come by every once in a while and settle down on his land for a few days. A gypsy woman told Julio she could see his future for a small fee. He said, "For money, I too can see anyone's future."

During the election campaign, Julio's house was plastered with posters of the opposition party. Dorival's grocery store across the road was plastered with government party posters. Julio said, "The better-off farmers like Dorival voted for the PDS (government party). Farmers like myself aren't doing well because of the banks. The banks are connected to the government and the banks want to ruin us. We didn't vote for the government party. I told Dorival this.

"During the elections, I went to the dentist. It's only during elections that dentists and doctors come here. A dentist from the government party set up an office in Edmundo's barn. When I walked in, there was blood, a lot of it, mixed with the hay on the floor. The dentist said he

would have to take out all of my seven teeth. I said I thought it was too much all at once, but he said they had to be pulled out. So he took them all out without anesthesia. I went straight home to sleep. I woke up in the middle of the night. My pillow was soaked with blood. Now I don't have any problems with my teeth.

"In the past, life was better. Things were cheaper. Everything started to change twenty years ago. [At that time, a coup d'état by the military against a democratically elected government occurred.] Things have gotten worse. They tried to help us with these bank loans. We didn't have them before. Now we're ruined. It started out as a good idea, but it ruined us. About ten families in the past year have lost their lands to the banks.

"The farms are going to ruin. How then will the people in the city get their corn and beans? Instead, what the government should do is not take our land away from us. They should just let us plant. If we stop planting, what'll happen to the cities?

"The peasant with a small parcel of land should just plant enough to get by. See what happened to José Antonio. He planted a lot. He lost it all because of the rains. Now he is sick. His nerves make him sick. The bank makes him sick. That's why he believes in all this nonsense the spiritualist says about the treasure. She just tells him what he would like to happen. We should forget about the past."

Crise econômica aumenta casos de fobia nos grandes centros

Doença é a válvula de escape para situações difíceis e a angústia do "stress"

(Translation: "Economic Crisis Increases Cases of Phobia in Cities. Illness is an escape valve for difficult situations and anguish due to 'stress.'")

"Maybe one year God will help me, and I'll hit the jackpot. I'll get a good harvest. I'll be able to pay back the bank. I don't like to owe money. I want to be free. Owing money strangles me. I cannot leave here until I pay back the loan.

"When the interest rate was 45 percent, we couldn't pay back the loan. Now it's 70 percent. How can we pay it back? In 1981, I borrowed 48,000 cruzeiros at 45 percent. That year I was able to pay it all back. I planted and I worked as a day laborer. I would earn 300 to 500 cruzeiros a day. I didn't run up a bill at the grocery store because every time I needed something I would kill a chicken or pig.

"In 1982, I borrowed 50,000 cruzeiros at 73.8 percent. That year the crops were bad and I only made 40,000 cruzeiros. I was able to pay off the interest on the loan. This year I borrowed 97,378 cruzeiros and used half to pay back the old loan. I sold two sacks of beans and made 11,000 cruzeiros. I have two-and-a-half sacks left. I need one sack to plant for next year and one sack for eating. Wheat and sugar are the only things I buy. I spend 15,000 cruzeiros a year at the store. Beer I don't drink because it's too expensive."

Julio told of a friend in the local town who would wait for the train to pull in. As work, he stole wallets. He showed Julio four or five wallets. He explained that he only stole them from the people who would not be needing money. Julio agreed with him.

"The most important thing for you to write about is farming. People who don't have any education can only farm. The person who's raised in the city is more intelligent. He has more education and gets paid better. They don't have to worry about working in the fields. In the city, you can be an engineer, a doctor, or a lawyer. I think they're better because of their education. A country person sacrifices himself and earns nothing. A city person earns enough and lives tranquilly. But on the other hand,

we don't have to work for the clock. In the country, we can sleep until seven or eight. We can either feed the pigs or go to the fields. If you're in the city, you always have to worry about the clock. The person that's most important is a lawyer, not an engineer, because he still has to go to the fields and measure."

Julio had a girlfriend who liked him, but didn't want to marry him because she was sick of suffering from farm work. She wanted to marry a man with a tractor. She did, but he's an idiot, Julio explained. "She's smart, but she stays with him because of the tractor." Julio said she was right in marrying the man with the tractor. It's a bad idea for farm girls to marry farmers because they'll only suffer.

"Who should they marry?" Maria asked Julio. "A journalist, a doctor, a lawyer? They don't want to marry a farm girl. She has no choice."

Maria's younger sister, Luciana, was going to school and there were only four months left for her to finish the year, but her parents needed her help planting and she was taken out of school. Luciana did first grade three times and was only able to pass once her teacher left and a better teacher came. The new teacher would like for Luciana to return to school, but Luciana only wants to return if she can study the entire year.

On our way back from a funeral, Julio and I walked along with the gravedigger, Nicolau, who said, "Farming is no good and raising pigs is no good. The only ones who win are the middlemen. We have to run around to find the lowest price on corn for the pigs."

Julio said, "I sold a 95-kilo pig for 1,000 cruzeiros. Edmundo, who bought it, resold it at 225 kilos for 25,000 cruzeiros. Same thing happens in farming. You work and maybe you get nothing that year and then you're indebted to the banks. If you do get a good harvest, the middleman starts making more money than you at the scales."

Nicolau said, "Farming is a good thing to do only once in a while. I'm going back to the city to look for work."

Julio said, "When God helps me, I'll build a good house and buy corn, beans, and chickens to sell. I just need 100,000 cruzeiros. I'd also plant potatoes and manioc. If God doesn't help me, I plan to sell my land, pigs, and corn. Then I'll move to somebody else's land and work for them. Or I will go to São Paulo and look for a job. Or you could find me a job in the USA. I'd sell everything, pay off the loan, and go with you. I wouldn't have any worries."

Maria said, "Why would the Americans want an old toothless *Bugre*?"

In Julio's first-grade book, the servants and workers are never white.

Doce de Abóbora
(Pumpkin Candy)

2 kilos pumpkin
1 soup spoon lye
4 cups sugar

Cut up the pumpkin into chunks
and place in cold water along
with the lye, which is put in a
cloth and squeezed in the water.
Leave overnight, then drain the
lye and water and wash the
pumpkin three times. Place two
liters of water and pumpkin and
two cups of sugar in a pot and
boil very well, then add another
two cups of sugar. Cook for one
hour.

Aurélio and
His Grandparents

Aurélio, Maria's cousin, came to visit for a few days. He slept on the kitchen floor. Aurélio is fifteen and was raised by his grandparents. His father died and his widowed mother had children by two different men and then she also died. His siblings were parceled out to different family members. The grandparents drink a lot. When his grandmother would get drunk and there was not any food, she would try to drown Aurélio and his sister who lived with them. A neighboring aunt, hearing his screams, would come to help them. She couldn't take them in because she had nine children. His Japanese half-brother was raised by a widow who took care of him and fed him.

Today, Aurélio beats his grandparents and steals their money. The other day, he got angry with them, but his grandmother was able to lock him outside of the house. Because he could not beat her, he destroyed her chimney from the outside.

Sometimes Aurélio goes to the river to spend the entire day collecting the prettiest but scarce shells. He will pile them on a rock and then smash them all. When he goes to the woods, he likes to find bird eggs or chicks and smash them with his feet. He once killed a neighbor's dog by clubbing it to death with a stick.

While José Antonio was away working for the timber company, a *gambá* (possum) tried to steal Maria's chickens. Aurélio tried to kill it. The *gambá* jumped onto his face when it was cornered and had no place to run to. Aurélio got it off his face and kicked it. It lay very still. He lit a match close up to the *gambá*. It winked. It was trying to make believe it was dead, so it would not be killed. Aurélio lifted it by the tail, then he called the dogs and let the *gambá* fall. The next day, the *gambá* was found dead. Its face had been chewed off on one side. The winking had not helped.

Aurélio and I walked around the woods an entire day and he did not kill anything. We had racing matches, which made him feel good because he always won.

The grandmother earns a living by sewing quilts. A quilt takes her two weeks to sew and she charges the equivalent of two dollars.

Sometimes she is paid in kind. One time she was paid in spoiled beans, which she herself had to shell.

The grandmother's house has two small rooms. The kitchen is one-and-a-half paces by five. There is a small table to the left of the door; on the right, there is a bench with a tendency to fall, a brick oven with a damaged chimney that now smokes up the house, a cupboard with one pot, a kettle, a scrubbing board, a bar of soap, and three chipped mugs. Above the oven, hanging from a stick, was a strip of bacon, ten by fifteen centimeters. The kitchen has an earthen floor, so mice and rain come in easily. The bedroom has two beds and a window.

The grandmother complained that her husband had spent all his monthly pension money (USD 21.00) on *cachaça*. (Although both had worked the farm, only men receive pension benefits.) He had not paid the grocery store, so now they could not buy anything on credit. The only thing he had bought with the money was that small piece of bacon. She did have a little money from a harvest she worked in. She spent it on a bag of flour.

During a rosary service, Marlice, Dorival's wife, said there were hardly any poor people in the countryside.

The grandmother said her husband was a hard worker, although he must work with only one arm (the other one was broken a long time ago and never set right). All he does now, she complained, is drink, pee, and shit in bed.

Her husband said he was going to leave her and go with a young woman who had dollars on an airplane. He then asked what a dollar was. When I showed him one, he said, "But it's only paper money!"

The Black Horse

There was a black horse that had not had his spirit broken yet. A young man on another horse was beating him hard with a stick to force him to move. He was a proud horse and tried not to be forced. But after three or four beatings, he would move a little. But every time the young man who was on the other horse went to beat the proud black one, his horse would move away and thus break some of the force of the beating. Later, the black horse was tied to a tree. He was trying to free himself from the reins.

Lygia and Denilson and What He Did to Lygia, Betina, and Vera

Lygia was married at thirteen to Denilson, a man in his twenties who had just returned from working abroad. He rents out his share of the land and does not work. He lives off his father's money. Once he sold a cornfield for 35,000 cruzeiros on a Saturday. By Sunday, he had 1,000 left. Lygia, his wife, is only allowed to go out with her mother-in-law to town and church. She wishes she would not have any more of his children. Denilson never comes home on Saturday, returning only on Sunday—drunk.

Lygia wants to take her daughter and leave him. But she explains that if she does, he will keep their child. She wants to give her daughter to her mother to take care of and go work as a maid. But he will not let her keep the child and so she stays. By law, the father has the right to keep the daughter and the mother the son. The mother would have to prove in court that the father is not fit to keep the daughter.

Betina is a young woman raised by Denilson; she took care of a store he once had. She had to weigh goods and add figures for the bills. She did not know how to do either at first, and if she made a mistake, she would be beaten.

On a rainy Monday when the local school bus, which is the only transportation between the town and the village, did not arrive, the mother of Vera asked Denilson, who was going to town in his truck, if he could take her daughter, who worked during the week as a maid with a family there. Vera was sixteen. As it is said, "He did with her what he wanted." And in town, he turned her over to a friend who took her to the capital city, hours away. He used her and left her in the city. She had to take the bus back to the town to go to work.

A Folktale

Francisco Malazar (Bad Luck Francisco) glued some one-cruzeiro bills to a tree alongside the road. He waited. A rich man came along who had a lot of money. The rich man was amazed by the tree. He asked Francisco Malazar if the bills only came in one-cruzeiro denominations. Francisco said to the rich man that as the tree grew larger, so would the bills. But the problem with this tree was you could not leave it alone for a minute. You always had to weed it or it would stop growing. The man begged Francisco Malazar to sell it to him. He agreed. Francisco Malazar left with all the man's money. The wind blew hard and the bills flew off and nothing ever grew back again.

Wladislau, the Pole

Julio wanted me to meet Wladislau, who is Polish, but explained that first he would have to go out to Wladislau's farm a few days in advance to warn him of our visit. Wladislau lives by himself in an isolated area and is wary of strangers.

The Polish began arriving in this area just before the 1900s. A large number of surnames in the village are Polish.

Wladislau's houses seem very eccentric to his neighbors. The barn and the bedroom make up one house and a smaller one has a kitchen and chicken coop. His chickens are tame and he is friendly with them. They like to sit on your lap, but it's hard to pick out their lice later.

The walls, table, and oven are covered with layers of grease. Wladislau has lived in this house for sixty years. On the walls are the mud houses of insects that have lived off the kitchen scraps. Wladislau once had a wasp nest in the kitchen and tried to raise the larvae, but when they got wings, they flew away.

The larger house has three rooms. The front room is for storing squash, tobacco, farm equipment, and medicinal herbs. The next room is for the rice, peanuts, and tobacco leaves that have not yet been rolled up for drying. The smallest room has his single bed and on a table, a potted pine sapling, statues of saints, a candle, and a jar of Vicks VapoRub. Pictures of the Virgin Mary, Our Lady of Aparecida, and Jesus hang on the walls. Behind the door is a cabinet exclusively for his fortune-telling cards. Cans of flour and sugar are on a bench in the middle of the room. All the windows are closed. He says it is better that way so sneaky people will not get in. Also, it makes it easier for him to hide.

He spread out his cards and began reading my fortune. He assured me that I was in love with a good person, but there was someone between us two who might even kill the good person. He said I would be successful in life. He gave me a formula of prayers to protect me on trips and another if I got married.

A little while later, a neighbor came by asking to be healed. Wladislau is also a spiritual healer. He took her into his bedroom and lit a candle. He held a picture of a saint over her head and began praying. He asked me to take a photo of him healing the woman's finger.

As she was leaving, she thanked him and promised to come back with some baked bread in return for his services.

Earlier, Maria had taken her son to another healer, Jandira. The walls of her house were covered with pictures cut out of magazines; one was of a Swiss chalet covered in snow. Jandira said that Maria's son, who had a cough, should walk in the dew at three in the morning. Then walk over three bridges and then take three sips of water.

On my last visit to Wladislau's farm, he rushed me into the kitchen, giving me some homemade cigarettes and tea. He started the pine nuts roasting and ran out into the other house. He came back with a radio and asked if I had ever seen one. He showed me how to turn it on, which knob increased the volume, and how to change the stations. He said he stayed up all night to hear the radio station from the capital and neighboring towns. He said, "I don't have a woman, so I will listen to the radio and enjoy myself." It cost him only 20,000 cruzeiros, he said. Julio said he had been cheated. He could have bought it for 12,000 cruzeiros.

As a going-away present, he gave me some eggs wrapped in corn leaves, a bagful of peanuts, pine nuts, and a squash. (During our first visit, he had also given me some eggs wrapped in the pages of a newspaper from the 1960s, realizing too late that on the outside page there was an advertisement for swimsuits and he was embarrassed for me at what he must have thought was improper.)

The da Silva Family

Maria took me along to visit a friend of hers whom she had not seen in a long while. She was a young woman in her early twenties. She had been working at Souza Cruz, a cigarette factory in town. When Edmundo, Maria's brother-in-law, was younger, he had tried to work there, but the fumes had made him too sick. The young woman was earning minimum wage. Half of it she spent on room and board. She worked the graveyard shift and could never sleep during the day because of the noise that the neighborhood kids made.

She was laid off and is now living with her parents. She had been expecting some benefits, but she would have had to travel to the capital to pick them up. She is supposed to receive this money every two years, but she could never pick it up when she was working. After she lost her job, she went. An official at the social security office said that although she had been eligible for the benefits, the law had recently changed and now she would no longer be able to collect. The benefits amounted to two months' wages. She said it did not matter anyway.

Agenor, a young boy, had come to visit. He had come in quietly and sat in the corner of the kitchen. I began to take a few photos, but he ran off. A few days later, I saw him outside the schoolhouse playing. Dorival's daughter, who is the schoolteacher, complained about all the fights Agenor started. After recess, he was still outside the school, so I went up to him. He threatened to run off, but first he demanded to know why my hair was so long. "It's nice that way," I said. He was almost satisfied, enough anyway to talk to me and explain that he had run off the other day because he had thought that because of my long hair I was a Gypsy and might kidnap him.

He then began his questions. He wanted to know how old I was and how many kids I had. He could not understand why someone as old as I was (twenty-one at the time) did not have any kids. He wanted to know if I did not like kids. Although he was still unsure if he should talk to me, he did tell me his age—ten. I was surprised because he is much smaller than Maria's seven-year-old son. Agenor was not in school, he said, "but my father is thinking about putting me in." I wanted to know if he thought it was a good idea. "No, because I have no pen." If he had one, would he go? "Yes, but then I would need a book. I already have

a pencil." I asked why his father did not buy him a book. He patiently explained, "He has no money and what he did have he spent on *cachaça*."

The entire harvest of Agenor's family had been confiscated by Dorival's workers because of debt at the grocery store. Dorival had it harvested because he was sure Agenor's father, Lourenço, would try to sell his beans for the official price on the market and therefore be able to pay off the entirety of his debt with Dorival instead of having to acquiesce to a lower price from him.

One moonless night on the way back from a visit, we were all startled by a movement on the road. Maria thought it was the spirit of Judas since the day his effigy would be clubbed to death was coming up. It turned out to be Agenor. He was an hour's walk from his home. Maria reprimanded him for being out so late on the road. She said one day an *onça* (jaguar) would eat him. She wanted to know if he was going to sleep at his relative's place. "No," and he was not going home either. As we passed Dorival's bar, Agenor saw his father and hid behind some trees. Dorival's daughter saw this and said that if he did not go to sleep at this relative's house she would tell his father where he was. She knew he would then be beaten severely. The bar had closed its door and Agenor's father was drinking outside because he gets too violent with the other customers. She then changed tactics and threatened to discontinue to give him any secondhand clothes if he did not go straight home. He said, "I don't need any shit from a snake." She kept teasing him and asked what he would do with no clothes. He said he would buy some. She asked if he had any money. He shot back, "Shut up, shell of a spoiled egg."

Maria was able to convince him to sleep over at her place. Zezinho, her son, complained about having to sleep in the same bed with a *Bugre* (Zezinho has copper skin and dark almond eyes like his mother and her entire family) because he probably had lice. After the children went to sleep, Maria said, "Agenor's grandmother is a *Bugre*. That's why he is so wild. He's half Indian. He walks around at night in the forest and isn't even frightened." I went to pick something up at Ana's house; she found out a *Bugre* was sleeping over at Maria's and warned me not to sleep there that night because a Black boy would be there.

Maria was to be the godmother of Agenor's youngest sister, so we went to visit his family. Maria brought along the baptismal clothes. The custom is that godparents are just a little better off than the family of the child. Nobody wants to be so rude as to ask someone so much better off to be connected with a family that is too far beneath them economically.

The dress almost fit the little girl and the sandals would with some thick socks. The child had a big lump on her head from a kind of parasitic worm. Manuela, the mother, said they had already taken eight out of there, but the bump was not going down so maybe there were still some there. But you have to wait for them to get to the surface before you can dig them out.

Manuela's house has two rooms, the kitchen and the bedroom with one bed. All seven members of the family sleep on this bed. There was some bacon hanging from the ceiling, but not much else. Dorival had taken everything.

There are a lot of stories about Manuela. Otávio said, "When she gets drunk, she takes a big stick and starts hitting the trees. Once when she was harvesting the corn, she got drunker than her husband, Lourenço. She must've drunk half a bottle of *cachaça*. She rolled down a hill. A neighbor went to help and started screaming that Manuela was dying because she was foaming at the mouth. She was just drunk. She is a dirty woman. Her neighbor had bought her a bar of soap to wash the kids, but she didn't. Lourenço, he drinks, but he washes himself every day. Women like that you have to run away from."

Maria told a different story. "Lourenço gets drunk a lot, about as much as Miguel, the *Bugre*. Sometimes he sleeps it off on the road when he can't make it home. When he does, then it's bad news for Manuela. Lourenço beats her and the kids. Now, she's smarter. If she hears him and he sounds drunk, she packs up the kids and spends the night in the forest, hiding from him. Lourenço tries to find her, screaming into the woods for her to come out, saying that otherwise it will be really bad for her. Manuela just waits until morning. By then, 'he's in a better mood.'" Agenor would rather live with his Uncle Miguel than at home.

Lourenço's father, Francisco da Silva, had stolen pigs from Carlos, Ana's brother-in-law, who got the police. They came by horse in those days. They tied up Francisco da Silva. Carlos had evidence, a pigskin that Francisco da Silva had forgotten to bury. Carlos made Francisco da Silva carry it with him back to town. Along the way, Carlos would stop near the grocery stores and call for everyone to come and see the pig thief. Francisco da Silva would try to hide his face under his hat and the pigskin.

The next time I saw Manuela and her family was at the baptism on Sunday. It turned out that all five kids were getting baptized at once.

We were waiting outside before the ceremony began. Agenor was playing with the other kids. He had on new clothes and had fallen into the mud. He did not get new clothes very often. He had been trying to be careful. Behind me was Wagner, a stocky young man of German descent; he was talking about Agenor, "If he doesn't want to get baptized, we'll tie him up like an Indian and force him into the church." And Agenor was trying to get the mud off his clothes.

Graça, who taught catechism at the church, would punish the children for any perceived wrongs by making them raise their dress or pants above the knee and then making them kneel on rose thorns.

I had wondered why Manuela was baptizing the children so late according to local customs. It turned out that Agenor had not been registered at birth and could not therefore get a work permit. The only proof he could then have to apply for one was through the baptismal certificate.

A few days before the baptism, at the bar, Wagner had been taunting Agenor about being so short. Agenor replied, "I am no little piece of meat."

There was a young boy born in 1964, the same year as the military coup. His workbook showed that he had been working in plantations and factories since the age of eight. He earned half as much as an adult. I asked José Antonio how much work can a boy like that do? He said, "As much as a man."

A Nice Home

The house of Lourdes and Edmundo is a comfortable one. The main entrance opens into the living room, which contains a red plastic vinyl sofa and two armchairs, a little coffee table with imitation tile work, and a Lucite-topped dining table with four red plastic chairs. The walls of the room are painted turquoise and the ceiling an older shade of the same color. No one uses the front entrance or the dining table. There is one window with orange shutters, and the door into the kitchen is also orange, as is the door into the eldest daughter's room. On the walls of the living room hang a wooden plaque, which holds a pipe; a drawing for Father's Day made by one of the children; and a plastic frame with a pink plastic crucified Christ on a white plastic cross against a glittery silver background. To the right, there is an image of Our Lady of Aparecida, wearing a black dress and a navy blue and gold mantle. On the bottom of that is yet another image of Christ and his mom in a green plastic frame with imitation silver on the corners and mirrors on the side. There is a photograph of the father when he was in his early twenties, wearing a blue suit coat, white shirt, and red tie. There is also one of the mother in her teens, wearing a blue dress with her hand lifted to her face showing her gold watch. Then on the next wall there are baptismal certificates of the children in gold-painted frames. On the Lucite-topped coffee table with plastic blue tiles and white daisies there is a white crocheted doily. On the dining table there is an embroidered cloth with red and pink flowers with blue mushrooms and red bows; the border is crocheted in red and on top sits a red plastic doll.

In the room of Fernanda, the eldest daughter, there is a bed, a night table, a dressing table with a mirror too low to be of any use, and a closet. The blanket has red and yellow tulips on a white background. On the night table there is a crocheted doily and on top of it a plastic doll with velvety paper clothes. On the dressing table, there are gifts from her uncles: a Mickey Mouse doll, a pink plastic naked doll with long brown hair, a plastic train, a bottle of perfume, placed on three white crocheted doilies. All the furniture has a thin coat of veneer. There are two windows painted orange and the room is painted pink with a green ceiling. In her closet, there is a two-foot-tall furry dog toy that was a present from her boyfriend.

Fernanda is studying in town. The well-off farmers in the area
send their older sons to the capital to study. The daughters are allowed
to finish the local grammar school, which is only until the fourth grade.
Then, if they want and their parents can afford it, they continue their
schooling in town. They are usually eighteen when they enter high
school. The teachers in rural schools are usually not well trained, and
when it rains, the students and teachers do not go to school. When it is
harvest or planting time, the children help out with work and lose one
or two months at school and then must repeat the year. When they enter
the schools in the city, they are very much behind the other children
and have to deal with the problems of being socially accepted. These
young women can only choose as their prospective mates those young
men who stayed on the farm, or those who stayed in town and did not
make it to the university in the city. There is a local college in town, but
it is very difficult for the country girls to be admitted. The young men
try very hard not to go to this college because it is only for becoming
a teacher. They would rather go to the agricultural school, but if they
graduate from there, they usually end up going back to their parents'
farm with ideas that are not welcomed. Or they can try to find a job in
the rural area, but there are not too many job openings.

Maria said that she hopes that Fernanda, who is sharp, does not
marry soon because then she will be throwing her education away.
But her father will want her to marry soon.

Adjoining the living room is the kitchen and from there a door to
the left leads to the master bedroom, which is painted pink, green, and
orange. The parents' bedroom has two windows and the bed is in the
middle with a large wooden cross on the wall. To the left of that is an
image of Christ in a white-and-green frame and to the left of that hangs
a white rosary on a nail; to the right, there is an image of a guardian
angel. On the night table on the left side of the parents' bed there is a
purple-and-white doily with a pink teddy bear placed on it. To the right
of the parents' bed is a small bed for their youngest daughter where
there hangs another image of Jesus, holding a staff and wearing a white
loincloth and red mantle, on a green glitter background surrounded by
a bunch of flowers. The little girl's bed has two thick quilts, as does her
brother's, which is on the other side of the room. There is also a fairly
new wardrobe, but it is made of flimsy material and is already falling
apart; the inside of the doors has been decorated with crayon draw-
ings by the younger children. On top of the closet, there are some old

boxes and a large plastic doll of a little boy with an accordion. There is a sewing machine, probably from the 1950s. There is a print on the wall of a farm family with two children at a picnic near a church with a tree branch with pink blossoms running across the top and a waterfall to the right. The children and mother are blond and the father has brown hair. They are eating apples, biscuits, and marmalade. They are dressed in the fashion of the 1950s.

Near the boy's bed is an entrance into the room of the three girls. Two beds fit snugly. Two sisters sleep on one that has a flannel sheet, which is repaired in a worn-out section in the middle with flowery cloth. The other sister's bed has a pink-and-red cover. There is a stick that hangs on top of her bed for her everyday clothes. There is a very banged-up bureau with three of the six handles missing. It is made of sturdy wood, but the kids have scratched it up. On top of the bureau is a basket of clean clothes; to the right of it is a sack of some more clothes. The only decoration is a picture of a white terrier with a red-and-white Scottish-looking cap with balloons falling on top of him. This picture is quite popular and is in several houses, sometimes in the bedroom, sometimes in the living room. The room is pink and the ceiling is green with one window and the door painted orange.

There are four entrances into the kitchen: from the terrace, the living room, the parents' room, and the backyard. The kitchen is the most important room in the house. Food is eaten here five times a day, and the TV runs by car battery there. It is spacious with enough room for everyone to be coming in and out without getting too much in each other's way. It is painted blue, with a green ceiling and orange-and-beige doors. The benches and chairs and kitchen table are painted light blue-green. There is an enamel firewood stove that is white with silver molding and a sink of red plastic veneer, but as there is no running water, the faucets are of no use and water is brought in from the pump in buckets. There is a cupboard of white and imitation-wood plastic veneer and it shelters fancy cups and glasses, usually gifts from relatives from the city. The three drawers in the middle have boards that are used for hot pots or for cutting bread or rope tobacco, and there are cooking utensils, schoolbooks and papers, keepsakes, and a slingshot. The cupboard also holds eleven jars for preserving food and there is also a clock on a white crocheted doily. On the very top, there are four smaller jars of pickles, a jar with a sweet potato seedling, and a bottle of apple cider, which is a present from relatives from the city. To the

left of the cupboard is a firewood box, which is also painted blue-green. On top of the stove is a 10-centimeter-long plastic key-shaped container that used to hold perfume.

On the opposite side of the cupboard is a small TV in a yellow case on a plastic-veneer TV table. Just to the right of the door that comes in from the terrace, there is a calendar with an image of Christ. Beneath it are small pages that can be removed daily, and it has religious images or historical ones with information about the moon in large letters in the lower left-hand corner, and on the back are riddles. Most of the houses I visited had these types of calendars, but they are rarely kept up to date. On the wall opposite the stove there is a framed picture of the Last Supper and alongside it, a kerosene lamp that no longer works. There is a lightbulb to the right that is also powered by the car battery. Behind the sink is a pantry with an old wooden cupboard painted green, as is the room. In the cupboard are jars of preserves of apricots, pears, peaches, plums, peas, onions, and other vegetables.

On another wall there is a sack to hold the *maté cuia* (the gourd for drinking maté) and a small sack that holds the toothpaste and toothbrushes. On the floor there are five sacks of flour, two of sugar, and one of wheat. Scattered on the floor are fifteen *machuchus*; twelve of these gourds will be pickled. In the cupboard there is also medicine, salt, eggs, polish, tomato paste, soup noodles, coffee, vinegar, cabbage seeds, soap, and a Styrofoam box with medicine for the cows.

The family is well off. A typical meal consists of rice, beans, manioc, potatoes, bread, and macaroni, and there is enough fried bacon for one teaspoon per person. Today, they killed a cow, so there will be a lot of meat. All the meat will be cooked in a large pot outside the house and then stored. Today, we had, in addition to our normal meal, meat and pumpkin candy. I bought two heads of lettuce in town. Most of the local vegetables were destroyed by the floods.

The pine floor of the house is a deep rich brown from years of waxing. The outside walls of the house are typical of the area: rough pine planks with slats to cover up the uneven edges so the wind and rain do not go through.

In the backyard there is the pump, a table for killing chickens and cutting up meat, and a water tank that does not work. There is a pantry that stores onions, potatoes, two pumpkins, a sack of garlic, one gas tank for cooking, three cans of pig fat, one sack of beans, one sack of

maté, and half a sack of tobacco. There is a bathhouse with an area of the back wall made into a sunken bathtub with four steps. It makes a comfortable bathtub. The shower consists of a bucket with a valve to control the water. You get one pailful of cold water and one kettleful of hot water. The water in the winter is too cold and the wind comes through the wooden slats of the bathhouse, which is not as well sealed as the main house. The shelves contain some old bottles of medicine, a potted plant that is not doing too well because it hardly gets any light, some soap, a long vine that is good medicine for kids who have intestinal worms, a bottle of oil, and two empty coke bottles. Three large nails are used as hooks with too many clothes on top. Nearby there is a niche for an umbrella, a little table for shoes, a pumpkin, and a can of polish behind the door. Near the outhouse there is a pear tree with the smell of over-ripeness, and a clothesline begins here. In the outhouse, pages from old schoolbooks or the leftover church pamphlets are used as toilet paper. There is a tacked-up picture torn out of magazine of a movie star that one day I had to use because there was no more paper. The outhouse is painted blue on the outside as are two of its walls with the remaining two awaiting paint. Farther on there is another pantry painted green with the door outlined in orange; firewood, meat, fat, old shoes, and basins are stored here. A brick oven for baking bread and biscuits is covered over so that it can still be used when it rains.

There are fifty chickens, four of which are the much-prized *angolistas*. From the right side of the house to the pear tree is a fence, but it is leaning and falls apart near the pear tree. To the right is a barbed wire fence that goes to the river. Then there are three acres of land, which provide firewood. There are also orange trees, pine trees, still some *imbuia*, and *bracatinga*, which is good for firewood.

Directly outside the kitchen is a terrace surrounded by a well-maintained white picket fence that stretches all the way to the living room, forming an *L*-shape. An outside cupboard holds a mirror with a glittery frame; underneath it is an aluminum basin and a cake of pink perfumed soap. Underneath, the shelf for the basin is the iron, a pair of sandals, and some tools. There are also four plants that are dying. There is a garden in front of the house: roses, daisies, carnations, and some other flowers that no one knew the names of. All are encircled by old car tires, except one rose bush that is encircled by a tractor tire. All the flowers are pink like the soap. There is an orange tree and a *novinha* bush, which has white flowers, and seven plants and a big

tank of oil. To the left of the garden is a cow barn with two entrances, one to the front of the house and the other to the backyard. Then there is a very large barn, one of the largest in the area. There is also a shed for the tractor; the only other tractor in the village killed a man riding on the wheel who had slipped underneath. Now every time that tractor goes out, it is pointed at and accused of having killed a man.

They also own seventeen cows, five horses, farm implements, one cart, and a light blue Fiat car.

On the outside, just before going into the living room through the main entrance, there is a small room with its own door to the outside. It is five paces by five paces. This is the little girl's playroom. She has a baby cart made of plastic, a straw crib, a homemade sink and cupboard of wood that is painted orange, which a cousin made for her. The playroom is painted yellow.

They have a white Pekingese and a big tan farm dog that Maria's cousin, Aurélio, broke the leg of; now it is swollen to twice its normal size. The mother wants them to kill the dog to put it out of its misery, but the father does not have the courage. There is already a puppy that is going to replace the farm dog. But he will die in another month because he had too many fleas and a visiting relative from the city put a lot of flea powder on him and his eyes got infected. The country host who knew better could not embarrass her city guest by telling her that so much flea powder would poison such a young dog.

The father has planted five eucalyptus trees in front of the house, but they decided they did not belong in Brazil and that it was better if they died. Now maybe he will plant Araucária pine trees. But I think he will try to plant American pine. There are lots of American pine plantations in the area and the wood is made into paper. The people here think how nice they look because of the magazine pictures of American pine trees covered with snow. Seedlings of both these non-native trees are given away for free by ProRural, a government office that is promoting, "reforestation" with plants that are lethal to Brazilian soil. His nephew is carrying out a campaign on his own to get people to plant the Araucária pine tree, which is native to the area and is a generous tree that allows other plants to grow around it. It is under threat of extinction.

The father also rents some land from a relative who is not interested in farming. On it, he grows rice, potatoes, beans, corn, onions, tobacco, and manioc. It was time for harvesting the potatoes; five men and two boys were working. They each had their own space to work

because they were getting paid by the sack as there were too few potatoes. The two strips of land where the potatoes are growing are divided by *mato* (bushes). The tractor goes around, tilling up the potatoes and everyone scrambles to gather these cold lumps. Two of his daughters are also working and a farmhand who only gets 10,000 cruzeiros per month. The workers get 200 cruzeiros per sack. Those working by themselves have half a sack now. They have been working for an hour and fifteen minutes. They will earn 100 cruzeiros per hour, which is high for here, but because of the rains and floods, there are only enough potatoes for one more hour's worth of work.

Edmundo, the father, said that the Itaipu Dam, which is nine hundred kilometers away, has changed the environment. He said that is why there are all these floods in the region. The director general of the National Institute of Meteorology informs that the Itaipu Dam cannot, under any circumstance, be responsible for the problems of the floods or any other climatic modification, according to research collaborated by technicians of world renown in this area.

Calídno Ramalho

No, he was not a statesman.
No, he was not a saint.
No, he was not a bank robber.

Calídno Ramalho was a peasant.

Calídno from Papanduva lived in the village for four years.

Lover of an old lady.
She laughed at your wake.
She did not come see your face.

They called you crazy because
You would get up to work the
Fields at four in the morning.

They called you not right in the
Head because you stayed out in
The forest for three days once.

You died at the hospital in town at 11:00 in the morning.

Wake: Wooden planks covered with a pink sheet
 And a blue one covered your body.
 They threw flowers, pink and red ones

 And *suspiro* blossoms on your chest
 To cover up your bad smell.

There was a wide very white cloth
Holding your chin.
There were four *pinga* bottles, one without a label,
For the candles.

There were five very old people at
Your wake, and many men, a handful of women.

There was a Mother Mary shrine at your head,
There were lots of children.

You were less than forty.
Your heart stopped.
No one from your family was told.

Your nine- and fourteen-year-old sons
Were working the fields for a pine
Tree plantation company for far less
Than the minimum wage.

When I took your photo you were smiling.

An old man behind
Was frightened,
Grabbed his cane,
Sat very straight
And was scared.

You were too much alive to die.

Did your woman stay with you
Because of your young body
And hard work?

Funeral: Two cartfuls of people arrived.
There was Maricota with a bouquet
Of marigolds, fuchsias, and *suspiros*.

She asked me to take a photo of her,
But not in front of you.
"It gives bad luck you know."

The men were in a hurry to bury you,
Because you were supposed to come at
11:00 (remember what happened the day
Before at 11:00?) and came at 2:00.

The cart came with the tired horses,
You were in a homemade casket covered
With blue cloth—handsewn.

You were in brown pants, and a work shirt.
Unbuttoned.

His body was bloated.
His fingernails were purple.

Your smile was gone, now you knew you died.

At the chapel, they touched your hands,
The little kids too.

The men waited till I had taken my last photo to cover you up.

But you did not care.

Everyone threw three handfuls of dirt,
"For luck you know," and Maricota three
Also and two marigolds,
And the men covered you up quickly.

There was no one whom you loved at your funeral.
There is no one who knows your history.

Joaquim Araújo said, "A good man lost."

That is all I know of your history.

Your last name is Ramalho, and you
Were from Papanduva. The only history
I know is that Papanduva was a
Settlement for Indians that were driven
From their land for the construction of
The cattle road.

The only other thing I know
Is that you retired because
Of your heart,
And your first pension check
Was to come this month.

But your heart that retired you,
Killed you,
The first month of your pension check.

Your name was carved into the wooden cross,
With a rosary bead hung on it.

After they finished covering you,
They threw flowers in the middle,
And stuck candles around them.

And your smile was lost because of none to mourn your history.

And in two years your name will no longer be there
On the cross.
And only Nicolau the old gravedigger will remember you.

You lost your history.

A Footnote

A young woman died, but I was not invited to the funeral. I asked, why did she die? How did she die? She was in her teens. Only during my last week there, someone said that they thought the young woman was killed by her father. They say that she was sitting in the wagon, minding the horses and waiting for her father to finish buying groceries. She glanced at a young man passing by on a horse. They say that her father saw her looking at the boy. They say that when they arrived at their farm, he took out his rifle and shot her. I do not know her name.

Biscoito de Amido de Milho e Coco (Cornstarch and Coconut Cookies)

2 eggs
10 tablespoons sugar

Beat well together and then add:

250 grams cornstarch
2 tablespoons margarine
1 tablespoon baking powder
50 grams or more coconut

Mix ingredients with water and 1 teaspoon milk. Knead, cut, and bake at medium heat.

Contraceptives

Women who use contraceptives spend 2,000 cruzeiros a year on the pills. The only pharmacy women can go to is in front of a church, and the owner has been told by the priest that if he continues selling contraceptives he will be excommunicated. The priest has targeted women who have few children, and therefore he has become suspicious of their use of contraceptives, to come to a meeting about contraceptives at the church, which will be held from 12:30 to 18:00. The men were invited to come from 8:00 to 12:00.

Women who take contraceptives to ensure that the family income can sustain the living children or to avoid bringing children into a violent household must do so furtively. They depend on each other to know the type of pills they should take as they would not dare go to a doctor. But there are different types of pills, and it is difficult to know which one to take. One young woman who wanted to leave an abusive situation had to stop taking contraceptives because she would wake up very dizzy and not be able to do her housework.

Alfredo and Beatriz

Alfredo likes to look up archaic Portuguese words in the dictionary. *Ardente* means burn and *esquamaritado* means you are removed from your place. He said since I lived outside of Brazil, I was *esquamaritado*.

This year, Alfredo voted for the opposition party. Since he had only recently become a resident of the village, his voter registration was still filed in his former town. There is no public transportation to town. Alfredo was going to pay Dorival to drive him to the highway, twenty-five kilometers away, so he then could take the bus to the town.

There are a half-dozen families in the village that own cars, but they all voted for the government party. When Alfredo asked Dorival to drive him to the highway, Dorival asked which party he was going to vote for. "The opposition," answered Alfredo. Dorival told Alfredo he could walk to the highway. Alfredo explained that he was going to pay for the ride. Dorival told him he could still walk. Alfredo walked the twenty-five kilometers, took the bus to town, and voted for the opposition.

Alfredo served in the army for the mandatory one year. He was in the kitchen detail. Once, an American general came to visit. Since it was a special occasion, Alfredo, a cook, was given a recipe for beef Stroganoff. He remembers there were fifty-two ingredients. At the time, it was the fanciest dish in Brazil, Alfredo said. After the meal, the general said he did not like it. Alfredo showed me a picture of him serving the general, and one of him and his friends lounging around the dinner table after the general left.

Alfredo showed me his keepsake box. There was a checkbook "from the time we used to have money in the bank." Four bullets, souvenirs from the army, which his wife polishes once in a while. A pen he got as a present and one metal earring painted gold that Beatriz, his wife, is going to send to the jeweler to melt down and make into a ring.

Alfredo borrowed money from the bank. He says, "To work with the bank is no good because it's just like working for another person." And on top of it all, he had to sell his horses.

"I'm going to have to rent out my house to keep up with the bank payments and the bank manager splashes me with mud on the road

with his Volkswagen. I pay the bank for him to ride in a car that throws mud at me.

"Everything has a commander and an assistant commander, like God and the devil, like husband and wife (not comparing her to the devil), and the Banco do Brasil has managers and assistant managers.

"The bank manager said when the harvest comes in, to pay the bank back first, then to pay the rent on the land. What's supposed to happen to the family who earns their income from the rent? The bank isn't going to go hungry."

The radio reported that the Banco do Brasil is sixth in the world in profits derived from interest rates.

I asked if Alfredo could farm without the bank. "No," he said. "I have no more money saved up, so I have to work as much as I can at odd jobs to feed the family. How can I farm without the bank? When I started farming, I could buy eighteen sacks of fertilizer with the money I got selling one sack of beans. Now it costs two sacks of beans to buy one sack of fertilizer. You have to get involved with the bank. You must be like a bee: 'You want honey, you will get sticky.'"

I asked him how much money he would need for food and seeds. Alfredo estimated, "Twenty-five thousand cruzeiros a month would be good with a 60 percent interest rate."

Alfredo said the minimum wage should be "40,000 to 50,000 cruzeiros a month (instead of 33,500 cruzeiros). Then I could pay back the bank. I desire to be rich and I will."

Since Alfredo has had to sell his horses, he will have to rent horses from a neighbor who, he says, "is a real friend. There isn't one person here who would lend his horses and wagon to anybody. After the rent on the land is paid, half of the harvest will be mine and the other half his."

As we are talking, Luizão, a neighbor, passes by. He wears loose cotton trousers, an unbuttoned shirt, a very wide hat, and seems to be gliding by. He builds houses and drinks. He charges four dollars and all the *cachaça* he can drink for building a house; for those who cannot afford it, he only charges all the *cachaça* he can drink.

Alfredo talked about another neighbor. "They say this place is good; they say no one goes hungry here. But I knew a man who made a living by making baskets and by healing people. He had three children who were deaf, mute, and crippled. He had no wife. They lived like pigs.

"This thing about healings—those who believe get better and

those who don't stay sick. I never went to get healed because I do not believe in it.

"The father died. The children were left with hardly anything to eat and were thirsty because they were crippled and couldn't fetch water. Finally an inspector came and took them to a hospital. Telling you this and remembering how they lived makes me want to cry."

Beatriz asked if I had ever been to the beach. She said she had seen it many times on a neighbor's television.

Beatriz had worked at Ouro Verde, a supermarket in a nearby town. At first, she priced the groceries, but her supervisor found out she did not know how to read numbers. She was demoted to shelving the groceries. It was hard work. One day she was resting and the supervisor came by and told her to see the boss. She was fired. When she asked him why, he said she did not need to know.

Beatriz said Julio insists that when the new grocery store opens in town, the owner has promised to put him in charge. Beatriz had told Julio her story to show him the owner would not put "people like us [illiterates] in charge of a supermarket."

She said a friend of hers had gone to work as a maid in town. She was told to make mayonnaise, which she had never done before. She confused one ingredient with a bottle of bleach because she could not read. The employer fired her.

Beatriz was very happy at moving to this new house because in the six months since they had been living here, Alfredo had not beat her. She said the house was blessed.

Beatriz is Alfredo's second wife. The first one left him because he beat her too much. Alfredo does not like to see anyone beat animals.

Beatriz complained about the village, especially the neighbor who lives opposite. They gossip about her and other men. Every time a man in a car or wagon stops to ask after Alfredo, the neighbor ironically asks, "Did they come to talk to Alfredo again?" One day, Beatriz decided to play a trick on this neighbor. Alfredo was told beforehand. She asked a friend to dress herself as a man. "She came to visit me and I met her outside. We pretended to kiss each other then she came in and I locked up the house." The neighbor gossiped. The trick was revealed and the neighbor publically embarrassed.

Beatriz said the only thing I could take back with me from the village was *saudades* (homesickness) because there was nothing else to take.

A VILLAGE ON THE COAST OF SOUTHERN BRAZIL

Hills Bananas Boats

Thirteen families that grow bananas.
Thirteen families that walk seventeen kilometers
And five hills to go to the grocery store.

Many men that walk seventeen kilometers
And five hills to enjoy themselves at the bar.
Many women, young and old, who stay at home on
Friday and Saturday with bad weather,
With children screaming in the house,
And no dry firewood for cooking.

The thirteen banana-growing families
Sell to the truck that comes from
A city close by.
The boat carries the bananas to the truck.
The bad weather comes and the boat does not go out.

The thirteen banana-growing families get sick very easily.
The men, women, and children complain about
The stabbing pain in the chest.

The teacher said it is tuberculosis.
The teacher says that with any little sickness they fall.
They are weak.
(That is what the slave owners used to complain about
with their indigenous slaves who became ill. They were
much happier with their African slaves.)

The bad weather comes and the boat does not go out.
The bad weather comes and more men, women,
And children get sick.

To take the boat, you have to get in the canoe.
But bad weather has come.
Thump, whump. The waves thick and strong hit the canoe.
But when the real bad weather comes,
The sick cannot take the tipping-wave canoe.
The sick walk or are carried to the highway.

A slippery-rain-dirt path is seventeen kilometers long.
You have to cross a place where the waves have cut
A deep path in the rocks.
Sometimes the water is up to your chest.
And you have stabbing pain in your chest.

The sick person gets to the highway
And waits for the bus to town.
But there will be no x-ray machine
To see if you have tuberculosis or not.

Old Lady Maria complains about tumbling down the hills
Because of the bad road.

The young men, they run down the slippery road.
Their agile bodies know the mud here.

The teacher has asked the town to cut a road to make it easier.
The teacher reminded the town that the people
Voted for the opposition.
The teacher reminded the town
That it was only six kilometers that were needed.

Senhor Vítor and His Family

Senhor Vítor lives in a village at the tip of a peninsula that juts out seventeen kilometers from a beach. It is a village of thirteen families.

Senhor Vítor is a widower who has nineteen children. Three bachelor sons and a married son still live close by. Another married son lives in town, but works the land at his father's during the week because he has not been able to find a job.

Senhor Vítor held up a 1,000-cruzeiro bill and asked, "Why do people work for this? Why do they suffer for this?"

To Plant Banana Trees
1. Clear the forest, but leave all the thick wooded trees.
2. When the banana trees are two feet tall, cut down the thick wooded trees. (If you cut down the trees as you are clearing the forest, you cannot walk through to get to the bananas because the forest grows back too quickly.)
3. Clear the undergrowth every three months.

The two thousand trees that Senhor Vítor owns require two men working twenty days to be gotten ready for their first crop. The banana stalks may be harvested once a month.

Benedito, Senhor Vítor's youngest son, went to cut banana stalks. Over the years, the weeds have built up layers of mulch, which is home to many snakes, but Benedito always walks very fast and does not sink into it.

Benedito cuts down the banana stalks and never pauses to look for snakes. He can carry seventy kilos of bananas in one trip to the house from the fields. I carried a ten-kilo stalk up a small hill; by the time I got to the house, I was running sweat and had to rest a long time. Benedito rests after every trip. He drinks coffee and smokes a cigarette.

Chopping eleven stalks of bananas and bringing them to the canoe for transport by boat to the closest beach by the highway takes Benedito

and his brother four hours of work. He complained that too much time is wasted looking for mature stalks, which grow only one to a tree.

When you carry bananas, your clothes get stained black and your hands become covered with sticky juice. You put an old shirt on your back and your head because of the juice. Then you wait for someone to load you up. I was looking at Benedito when his brother was loading him up. After the fifth stalk, he started letting out his breath because of the weight. There was one time he opened his mouth and all of the nerves of his face let go from the tiredness of carrying that load. He is eighteen, but from his face you would think that he is forty-five; it is all wrinkled. His legs are too thin and his stomach is flabby. His body is that way because of the high carbohydrate diet they consume. He has one eye that is crossed. He is very shy. He can carry up to ten stalks on his back down a path that is dangerous because of the rains.

That day Benedito and his brothers made eight trips each from the house to the canoe (a five-minute walk), each time carrying about eight to ten stalks (seventy kilos).

For every dozen stalks, Benedito receives 2,500 cruzeiros from a company that sends a truck to pick up the bananas at the beach that borders the highway. Benedito must deduct from this the 70 cents that his brother, who owns a boat, charges to transport every dozen stalks from the village to that beach. Benedito thinks the bananas should be sold for 5,000 cruzeiros a dozen stalks and more should be paid for the transportation because they are working too hard for what they are getting. On the next trip, bananas will go up to 3,000 cruzeiros a dozen stalks.

Rui, another of Senhor Vítor's unmarried sons, said that sometimes when they are unloading bananas, a tourist would come to see them and ask them to pose for a picture when they are weighed down with seventy kilos of bananas.

Senhor Vítor had worked in banana plantations in a port city farther up the coast. He said, "When you are working for yourself, it's good because you can rest when the load gets too heavy, but at the plantations you can never rest until the work is done." The bananas he carried went to Argentina, the United States, and Europe. Senhor Vítor said the money he earned at the plantation was only enough to buy food and cigarettes. Sometimes he and his friends did not have fare money for the ferry that took them to the port city. They would then have a three-day walk to the plantation.

Senhor Vítor sold five of the seven acres of land he owns for 2.2 million cruzeiros (USD 4,400) in 1979. By 1983, due to inflation, it was worth 7 million cruzeiros. The new owner is trying to get an American company interested in the area. When this deal is transacted, Senhor Vítor and his family will move to town where they have already bought a small house.

Rui said before his father bought the house, he did not know what a cistern was, but now he knew even what "light" meant. (The name of the electric company in town is in English instead of Portuguese.)

Senhor Vítor and his sons still work the land. In 1983, they planted 12,000 shoots of manioc, 2.5 acres of beans, and 2.5 acres of coffee, but the rains destroyed half the crops. There are also fruit trees, chickens, and ducks.

The main staples are rice, beans, and manioc with a little meat or fish. Every acre of manioc yields ten kilos of manioc flour, which lasts Senhor Vítor and his family one month. Fifteen kilos of beans lasts his family for two months. Senhor Vítor said until the 1960s, he would plant up to fifty acres of manioc to sell. But today he cannot afford to sell it at current low market prices.

Senhor Vítor had owned a boat with a motor. He would catch fish to sell in the market. He would have to go too far out in the ocean, and the price for the catch was not even enough to pay for the fuel, so he sold his boat. Senhor Vítor and his family make about 500,000 cruzeiros a year.

Senhor Vítor's house is typical of the area. The style is called *pau-a-pique*, a wood-and-mud house with some seashells. Thick beams serve as posts while smaller ones are tied horizontally to the posts then vertical ones are tied to these with *ripa* (strips of tree bark). Mud is thrown onto this structure. The consistency cannot be too thick or thin. After a few years, the hardened mud starts to crack off.

Very few houses have sofas, armchairs, or beds. At Senhor Vítor's house there are two tables, benches that are used for storage, six short-legged stools, and straw mats for sleeping. Floors are kept carefully swept, especially if it is dinner time. Pots, pans, and plates are placed on the beaten earthen floor, and the family sits around in a circle on their stools. Supper is usually *azul marinho*, a fish, banana, and manioc stew served with the liver and intestines of the fish.

The people who live along the coast like Senhor Vítor and his family are called *Caiçaras*. The dictionary defines *Caiçara* as a "vagabond,

tramp, scoundrel, or brutish person of the backlands." *Caiçara* originally meant a nation of indigenous peoples who inhabited the coast areas of São Paulo State. Today it means the descendants of these indigenous peoples. In this village, the term is used proudly. If a young boy can run around in the cold rain with no shirt, the mother will say, "He's already a *Caiçara*." I asked Rui how come he knew the forest so well, he answered, "I'm a *Caiçara*." None of them are aware of its original indigenous meaning.

POSTSCRIPT: 2013

Caiçara is now a term that refers to European descendants who live on the coast. This is a very recent change as formerly *Caiçara* was a derogatory term for a person who looked physically more or less indigenous and who lived on the coast. Previously, a European descendant would not and did not use the term *Caiçara* to refer to themselves and instead identified themselves as fishermen, *pescador*. It is the elite descendants of Europeans in Brazil who traditionally control the discourse; however, since it is now fashionable to be ethnic, the identity of the "other" has so successfully been taken over that in the new public imagery of Brazil, a *Caiçara* is most often portrayed as a Brazilian of European descent and no longer as an indigenous person.

Local Fish from the Sea

Boto

Cação, Caçoá, Cavala, Chioba

Espada

Garoupa

Jaguareça, Jurico

Maeba

Namorado

Obeba

Pampo, Parati, Pescado, Pirajica, Provína

Roncador

Salgo, Sanebiguara, Sardinha,
 Sarnepinto, Sororoca

Tainha

Vitolest

Cenilda and Her Family

Cenilda is Senhor Vítor's daughter-in-law, married to Ramão. The first day I went to Cenilda's house, she said not to notice the mess. "It's like Indians live here." Cenilda has seen photos of Indians in the United States. "They were wearing old clothes and the little kids walked around in torn shirts and shorts." Cenilda is a descendant of indigenous peoples, Blacks and Europeans, most probably Portuguese. Her daughter wears a dress that has no buttons in the back and the lace on the edge is unraveling. The little boys wear torn shirts and shorts. Cenilda's shorts are ripped in front and on the sides. Her ankles have too many *borrachudo* (sand fly) bites. The flesh is lumpy with bites over bites over bites. The town people say that the *Caiçaras* are used to it. But Cenilda still scratches the bites and they bleed. Her children's legs are bleeding from fresh bites.

Cenilda's house is also made of *pau-a-pique*. *Saúvas*, large red ants whose bites are extremely painful, infest her home. The floors are covered with them. They are climbing on the walls. They are under the covers, the mattress, pots, and clothes. Cenilda sets fire to the ants every day, but the live ones continue to crawl over the dead ones. There is a small bat that lives in the house; he eats the *saúvas*.

In the living room, there is a pile of seaweed on the floor. There is another pile on the only furniture in the room, a table. The seaweed is drying. Normally, it would be out on the roof, but it had been raining lately. The seaweed grows from May through August. They can get 2,000 cruzeiros per kilo of dry seaweed. If it rains, the seaweed does not dry and spoils. The Japanese in town buy the seaweed to make into a paste.

This seaweed, called *limo*, grows on the rocks near the waves. If all the seaweed is growing in one place then five kilos can be cut, but it is not usually the case since everyone along this coast harvests *limo*.

Because of the rocks and the rain, a man had fallen into the sea. He was dragged along the rocky coast for a mile. He was badly scratched but alive. Once when Cenilda was cutting *limo*, a wave sneaked up and dragged her in. She cannot swim very well, just enough to keep from drowning. Her pregnant sister-in-law had been working with her and did not know whether to jump in or not. Cenilda's mother,

who was also with them, did not know how to swim. Finally, the sister-in-law jumped in and saved Cenilda, but just as she was coming up, she stepped onto sharp rocks. Her foot was swollen for three days. That day she also lost her wedding ring.

The family's income is based on the boat, seaweed, bananas, and a little money Ramão makes taking care of some land owned by a speculator. The total income is about USD 90.00 a month. This is the highest income in the village. Two-thirds of it is spent on food.

Cenilda and her family of seven consume:

5 kilos of sugar every six days
1 kilo of beans every day
1 kilo of rice every day
½ kilo of coffee every five days
1 can of oil every four days
3 kilos of salt every month (if no fish is salted)

Cenilda went to town. She was at the bus station waiting for a bus to take her to the highway so that then she could walk back to the village. A young woman selling clothes came up to Cenilda and asked if she would like to buy any. Cenilda said that she had just bought some clothes and the rest of the money was for medicine. The young woman said to Cenilda that her sweetheart had not come during the weekend with money for her so the only thing she could do was sell clothes on the street. Cenilda asked the young woman who her boyfriend was. "Ramão, the manager of the lands owned by that Japanese man in that village that is after the last stop on the bus." Cenilda said the only person named Ramão in that village was her husband.

The young woman grabbed Cenilda by the shirt collar and told her to leave him alone. Cenilda reminded her that she was the wife. The young woman said Cenilda did not make love with Ramão the way he liked: she was not any good in bed. She did not know how to be loving. She did not know how to caress. The young woman taunted Cenilda to come and see the bed that Ramão had bought for her. She did not think even Cenilda had a bed like that.

This was in the bus station. Everyone was listening. Cenilda cried all the way home. She told everyone in her village.

Rui went to talk with his brother Ramão and asked him, "Now, how are you going to deal with your wife if she takes a lover?" Ramão said it

was different for a woman. Rui said in those matters there is no difference between a man and a woman.

Cenilda said that when she first married Ramão, he had a flat stomach. Now he was getting fat. She also said when she first met him that she weighed fifty-three kilos but now at the age of thirty-three, she weighed sixty-two kilos.

While I was there, Ramão went into town to see his young woman. Cenilda, in the hopes he would come back that day and make love to her, had washed and set her hair and painted her nails with pink polish. It was Sunday. Ramão returned Monday night.

In a conversation with a young unmarried woman, Cenilda said, "Have you ever seen a man naked?" The unmarried young woman replied, "No, I have never seen one." Cenilda explained, "It is not very pretty."

After Dinner

There is a bar one hour's walk away. Warm beer and *cachaça* cost twice as much there as in a grocery store in town. Most of the path along the way is good except for the rock that has water running over it. On the way back, it is worse because you are drunk and there are two steep hills to go down and the paths are treacherous from the rains.

Rui had worked as a cook in the beach restaurant in the nearby resort town. An American came to eat there and ordered stuffed shrimp. The chef, Jair, Rui's cousin, said, "You don't have to put sugar in candy for Blacks." (A racist saying that means a Black person—and therefore poor and unable to afford sugar—would not know the difference.) The American was writing a cookbook on international cuisine. He was also the owner of a catering company. The American was impressed by Jair's cooking. He invited Jair to come with him to the States to work for his company.

Jair quit his job and left to meet the American in the city. On the day he was to leave, he got drunk and found himself a woman and refused to leave. Jair died at thirty-seven from 51 (a brand of *cachaça*).

Rui pointed out that 70 cruzeiros can buy you a shot of *cachaça* or a .22 bullet.

Years ago, at a dance held in Senhor Vítor's house, a fight broke out between two men. The mother of one of the men took her son home. The son said, "If you take me home now, I will only kill him some other time." Later that night, the son went to the house of the man he had argued with. That man had seen him coming and ran off into the forest. His pregnant wife answered the door. The man with his cocked rifle asked for her husband. She said he had gone into hiding and she had nothing to do with the argument. He said, "I came to kill your husband, but since he's not here, I will kill you so as not to waste the trip." He shot her in the chest. The man was in prison for twelve years where he learned to read and write. Today he owns a construction company. He is the most prosperous person from the village.

Senhor Vítor said that some years ago the army came to the village hunting down a communist. The army captain explained that a communist is a person who steals government property and tries to sell it. Years later, Senhor Vítor spoke with the communist who said that the

army eventually found him and what they put him through was not for a human being to suffer.

Operação Bandeirante was an organization created in 1969 by the military to hunt for communists. *Bandeirante* originally refers to the Portuguese who arrived in Brazil in the sixteenth century and made expeditions to kill indigenous people for their lands or hunt indigenous peoples to make them into slaves.

Cenilda said, "My great-grandmother was Indian and my great-grandfather was Portuguese. In those days, people used to leave *cachaça* and tobacco for the Indians. [An ambush tactic still in use today to capture or kill indigenous people.] Usually two or three would come and get it, but one day, many came. The men here encircled them. Among these Indians were a young woman and her parents. They were taught the ways of the neighborhood. The young Indian woman married my great-grandfather. I remember seeing her when she was ninety-five years old. She wore her hair loose. It would come down to her waist. It was black and there wasn't one white hair."

Rui: I think I have more Indian blood in me.
Cenilda: I don't know.
Rui: In town, they say my hair is too straight for the color of my skin.

Senhor Vítor said, "My wife was very sick. At the hospital, she didn't get better. She had diabetes. On the radio, I learned about a Protestant minister in the city who healed people. His church is very big. They said over the radio if you brought a piece of clothing of the sick person, the minister would pray over it and the person would get better. I brought an old dress of hers, but she still died. Maybe it works for some people, but she died."

Senhor Vítor continued, "When I was sick with pains in my heart, I went to the hospital, but they didn't help. Afterward I went to the spiritualist. She said while the heart beats strong, everything is all right, but when it starts beating slowly and stops, then you have to worry. Who doesn't know that?"

Rui talked about a spiritualist who could drink a whole bottle of *cachaça* when in a trance and not get drunk. Senhor Vítor said he knew a missionary who could do the same thing and he was not even in a trance. Rui said you could not talk about a priest and spiritualist in the same sentence. Senhor Vítor said, "Why not? It's all a lot of silliness."

The Teacher

On the bulletin board of the school there is a poster of a boy taking a shower. Not one family in this village has a shower. Another poster demands that you use the toilet and not the woods for sanitary reasons. None of the families here have a bathroom or outhouse. They have the forest.

There are about a dozen children in this school. Most of them are in the first grade. There are only two in the fourth. Many of the students become discouraged in the first grade and drop out.

The teacher complained about the students being dumb and too slow in learning their lessons, but he teaches them things that have nothing to do with them. They try to be interested, but they have to pay too much attention to learn nothing of use to them. The teacher threatened the kids with an examination if they did not do better on their homework. The children here have never needed to prove how much information they know. Threats of examinations are useless. When the teacher realized this, he threatened to do away with the free lunch if they did not improve. (Rural teachers agree that the only reason most children come to school is for the free lunch.)

While I was there, the teacher gave an end-of-year examination. The first graders had to read aloud the following words: *tiba*, *rua*, *ruido*, and *seda*. Only one of these words is part of the village vocabulary. It is *ruido*, which means noise, but they usually use the word *barulho* instead. *Seda* is silk. No one here has ever touched it. *Tiba* means a place for the accumulation of things. I do not know if you can use it for the storage pots that hold manioc meal for the month. *Rua* means street. There is no street in the seventeen kilometers from the beach on the highway to the village. Quite a few of these children have never been to town.

One question the exam asked of the second graders was "Where does our food come from?" Most families here grow coffee, beans, and manioc, but rice, meat, oil, salt, soap, and matches must be bought in town. The choices of answers were "town or country." Either of these would have been correct, but for the teacher only "town" was correct.

One of the classes in this government school is religion. You must attend every class to get a passing grade. I asked the teacher what happened if a student was not Catholic and did not attend the class. He said he would ask if they prayed and then it would be all right.

On a string that crosses the classroom hang two magazine cutouts. One of them shows flamingos sunning themselves on a well-groomed lawn. The other shows a chubby blond, blue-eyed boy with a puppy. Not a child in this school is blue-eyed or white. There are no lawns or flamingos here. Only the teacher is blond with blue eyes.

Darcilea is Cenilda's oldest child. She is eleven years old and in the second grade. The teacher came up to check her notebook. She was working out some math problems. She tried to cover up her work from the teacher. He said hiding it would not help. He picked up her notebook, looked at her work, and threw it back on her desk. He said there was no comment to be made about her work. Darcilea lowered her head. She was going to cry, but she held back her tears.

The teacher gives the kindergarten children art lessons "to develop their motor ability." Mimeographed drawings of elephants and rabbits are given to the children. There are no elephants or rabbits in the village. The outline of the figure helps them learn about contour, according to the teacher. They glue seeds of the *arrueira* trees on the outline. The seeds are red and the *sabiá* (thrush) likes to eat them. The children color in clowns, but they have never been to a circus. They connect the dots of a drawing of a car, but there are no roads and cars never come here. The children draw on the back of campaign posters of the right-wing party in power, which the teacher gets from the education office.

Young Women

Leticia is the only single young woman in the village. She does not need to help with the farm work because she has brothers. Her mother washes the clothes and Leticia helps cook. On the walls of the main room are pinned-up cutouts of flowers and of women from fashion and porno magazines alongside pictures of the saints.

Leticia is looking to get married. She does not want any of the local fishermen since she would like to live in town. She wants to marry the schoolteacher, who is not interested. Her two sisters live with their men, but are not married. One sister is eighteen and is five months pregnant and lives with a local fisherman. The other sister lived with a young man from town, but he left her to go look for work and was away for five months. Her father came to get her, but the young man's father explained that she was pregnant. Her father said he would not take her back like that so she had to stay with the young man's father. Her man finally sent for her. He had found work at the port. She had her child first and then went to him. The young man's father said if she stayed, he would take care of the child. She left and never came back.

From the village, you can see an island where three families live with a half-dozen kids each. There is a school on this island. A boat comes once a month to take the teacher into town for two days. The teacher on the island went crazy, the people there said. She burned the school and tried to burn herself. Then she went to live in a cave. The school inspector reported it differently. He said the villagers had tried to set her on fire because she would sunbathe in the nude. This year no teacher wants to go to the island.

Birds of the Village

Alma-de-Gato, Andorinha, Anu, Araçari
Baitaca, Beija-Flor
Caçaroba, Carapeá, Coleiro, Coriabu, Coruja, Cuhuria
Jacu, Juriti, Juruna
Macucu
Papagaio, Papa-Banana, Passaro-Preto, Pato d'Agua, Pavó,
 Periquito, Pica-Pau
Sabiá, Sairá
Tesourinha, Tico-Tico, Tié, Tifela, Tijitica, Tiriba, Tubaca, Tucano
Uru, Urubu
Vira-Bosta

Senhor Vítor was going to add seagull to the list, but he said it was not a special bird and it probably existed everywhere.

Snakes

Rui was bitten by a *jaracuçu*. Ramão, who had good teeth and gums at the time, sucked the venom out of the wound. (If the gums are not healthy, the venom will enter the bloodstream.) Rui said getting bitten was his own fault because he had not been wearing boots. It would not have helped. He was bitten on the upper thigh and the boots only come to the knee.

Ramão took him to the hospital. Rui was given serum. He was told to put on a hospital gown and stay overnight for observation. He refused the gown. He wanted to continue to wear his shorts and no shirt. The nurse said if he wanted to keep his shorts on, he would have to spend the night in the ward for those with mental disorders. He went there.

Ramão brought him five packs of an expensive brand of cigarettes as a present. The doctor saw Rui smoking and told him it was not allowed. He then noticed the brand and said, "So you earn enough to smoke these?" Rui said to the doctor it was not any of his business.

Cenilda's mother was once bitten by a snake. She was taken care of with a home remedy of herbs. Pregnant wives or their husbands could not visit her according to village belief. Only close friends were allowed to see her. Each visitor would bring in a cup of water, which she would drink from three times. After she drank the water, they were allowed to speak with her. She stayed for forty-one days in that room with the shutters closed to keep out the light.

Cenilda said there were other cures for snake bites. If bitten, you could drink one shot of *cachaça* either with smashed garlic or with the heart of the snake that had bitten you.

Senhor Vítor does not like to kill good snakes; neither do his sons. There was a four-and-a-half-meter-long *muçurana*, also known as the field cleaner because it kills venomous snakes. Senhor Vítor did not let anyone kill it, but one day some kids got to it. He said it had been a good snake.

Rui said sometimes you can find a *cascavel* (rattlesnake) in the fields. It shakes its rattle to warn you away. When you hear it, you should just keep clearing the land, leave it alone, and nothing will happen to you. You do not have to kill it. Just walk around it.

Cenilda's grandmother (the one who had been a slave) had told her about the creation of the snake. God created the lizard and gave him legs. The snake saw the legs and asked God for some. God asked, "Why do you need legs?" The snake said, "For chasing people." God gave the snake legs made of clay. The first river he crossed, the legs melted away.

Snakes around the Village

Caninana, Cascavel, Cobra Coral,
 Cobra d'Agua, Cobra Verde
Jararaca, Jaracuçu
Muçurana
Urutu, Urutu Cruzeiro

Slavery

The grandmother of Cenilda was a slave. (Slaves in Brazil were emancipated only in 1888.) Whenever her owner wanted her to get pregnant, he would tie her up to a tree so a male slave could rape her.

(I once met an artist in Mato Grosso do Sul who had inherited some lands from his family, including a property that one might call a "rape plantation.")

POSTSCRIPT: 2013

A *quilombo*, a community consisting of Black runaway slaves, has existed in this area since the mid-nineteenth century, thirty years before the end of slavery. In 2006, the Brazilian government, through its recent policy to promote racial equality, recognized a section of this area as belonging to the former slave community. It is now part of the UNESCO Slave Route Project: Resistance, Liberty, Heritage, which maps the paths of slaves and their cultural influences. Unfortunately, this has resulted in landless Afro-Brazilians who are not from this area arriving and claiming recognition as being members of this former *quilombo*.

A Short Conversation in the Forest

Rui: When we hunt in the forest, we eat palm hearts to stop our thirst.

A little while later.

Rui: The Indians used to eat palm hearts to stop their thirst when they were hunting.

Some Plants and Trees That Surround the Village

Bastão, Bauva, Bicuiba, Brejaúva
Caeté Banana, Caeté Imbira, Candiúba, Canela,
 Castanha, Cedro
Figueira
Guaraguãta, Guarecica
Inga
Jacaré
Palmito, Peloteira
Samambaia, Sexta-Fios, Sibiuva
Tarumã, Tocu

Some Animals around the Village

Anta
Cabrito do Mato, Cachorro do Mato, Cutia
Gambá, Guatika, Guaxini
Irara
Lebre, Liraninha, Lontra
Mono
Onça, Ouriço
Paca, Pirara, Preguiça
Tamanduá, Tatu
Veado

Two Neighbors

Senhora Neusa lives a thirty-minute walk from Senhor Vítor. Hers is the only house on a desolate beach with a waterfall.

The household income is half that of Ramão; they spend far less on food, although they have more children. Senhora Neusa also has to spend extra money on medicine for their oldest child, who has tuberculosis. The schoolteacher said the community tried to hide from him the fact that many people here have TB. He said they want him to believe the medicine is for the common cold. "Who would spend 3,000 cruzeiros on a cold medicine? And what is the stabbing pain in the chest that doesn't let them work?" The schoolteacher thinks all of Neusa's children have TB. Senhora Neusa does try to share the medicine. But one bottle is supposed to last only one week and she makes it last for the entire month among all her children.

The two eldest children of Senhora Neusa help carry bananas to Ramão's boat. They are ten and eleven. There is a steep hill to climb. It takes ten minutes to get up it, resting two or three times. The boy carries one stalk, the girl two stalks. They walk thirty minutes to get to the beach where Ramão's boat is anchored. Senhora Neusa lives in front of a beach, but the undertow is too strong for a canoe or boat.

On top of one of the hills in the village there is a house with large white letters painted on the side. It says BARRACÃO (Big Shack). The man who lives here cuts only two or three dozen stalks a week. His income is about thirty dollars a month. He spends most of his money on liquor. The schoolteacher has to remind the community to feed the man's son. Cenilda tried to adopt the boy, but the father refuses to give him up.

His wife had been a sick woman, often in the hospital for months at a time. Cenilda said, "At the hospital, the woman got to rest and eat three times a day and would get better. But then she'd come home, she didn't have enough to eat, would work too much, and would get sick again. She died."

Manioc

Manioc is a thick white starchy root that can be eaten cooked or made into flour, depending on the variety. The one with thick brown bark is good for boiling and frying. The other, "fierce manioc," has a thin red bark and its juice is poisonous, but it is good for making into flour. Most villages no longer grow "fierce manioc" because the flour is so readily available in stores. It is also too much trouble to grow on a farm. Livestock eat it and die. In the village, the land is too hilly, with cliffs in unexpected places, and there are too many parasites, so there is not much livestock and "fierce manioc" can be grown.

To make flour from "fierce manioc," you begin by scraping off the bark. Then it's grated by a machine powered by a wheel that the men turn while the woman sits on the machine and holds up the manioc to the grater. The woman's job is very tricky because her fingers come in direct contact with the metal teeth. She starts off with two pieces of manioc root; when one piece gets too short, the other is used to push the shorter one into the grater. It is hard for her to see what is going on because she becomes covered with grated manioc as some flies off the wheel before it falls into a tub beneath it.

Next, the grated manioc is stuffed into *tipitis*, baskets that look like car wheels. The *tipitis* are dragged to the presser, and two or three are piled up on top of each other. A large wooden screw, one and a half meters tall, puts pressure on the *tipitis*. They are left in the presser overnight. Every once in awhile, the screw is tightened, forcing more poison juice to pour out into a small wooden tub just beneath the *tipitis*. The women then toast the grated and sifted manioc in a one-meter-wide skillet, which is built over a clay oven. The men keep the fire going. The poison juice is discarded or stored to be used as insect poison, but the *polvilho* (the manioc that has collected and has soaked overnight in the tub with the poison juice) is used to make *bijú* or *bolinho*.

A mixture of *polvilho* with some toasted manioc flour is sprinkled into a thin layer on a large skillet to make a *bijú*. The *bijú* is toasted on one side, then the one-meter-wide cracker is turned over to be toasted on the other side.

A *bolinho* is a mixture of *polvilho* with enough toasted manioc flour to make a patty five centimeters thick. The patty is wrapped in banana leaves and baked in the coal embers.

Rui on Politics

"I voted for the opposition party because their people came to the village twice to campaign. The people from the government party have only come here once in five years. You'd think the government party would come more often. They've never done anything for this place and never will.

"I was responsible for getting the votes for the opposition party in here during the elections. I was captain of the soccer team, so I controlled forty votes. I went to the headquarters of the different parties to get T-shirts and sneakers for our team. I went to the office of the government party candidate, J.B. He asked how much it was going to cost. He just took out a bunch of bills to pay for everything, but his assistant said, 'No.' He explained that T-shirts and sneakers were available at another office and had to be requisitioned there. Later on, J.B. did come to our village to give me a soccer ball. I said he could give it to me, but our household was voting for the opposition. I said he could go to Ramão's house since he was going to vote for the government. J. B. went and made a deal with Ramão. If J.B. won, Ramão would be made the path inspector for the village." (This is a much-desired position in the village. The inspector checks that the two government workers maintain the path as there are no roads.)

"I went to the office of L. (the opposition party candidate). He promised the soccer equipment, but he didn't deliver. It was F. P. (another opposition party candidate) who gave us the equipment. The entire soccer team voted for him. F.P. is a good man. He gave his men 10,000 cruzeiros for helping him get elected. We'd take voters to F.P.'s house and they'd drink and eat, then we'd take them to vote.

"I voted for F.P. although I knew he wasn't going to do anything for our village, but in the town, he'd be a good contact. I'd have voted for the opposition even if they hadn't given us the sneakers and T-shirts. During the entire time the government's been in power, nothing's been done.

"L. may have helped our village, but for me and my family, that's something of the past. It doesn't matter if he would've opened up new roads. From here to the highway, there isn't one family who still owns their lands. All of it's been sold. I need someone influential in town. The village is the past."

Footnote

L. was a city councilman who was hunted in 1964 by the military and escaped the city to this town on the coast. He owned a piece of property on a remote beach. Senhor Paulo, a political colleague who was also *clandestino* (incognito), saw a small group of Guarani people living precariously in a swampy area. He arranged for L. to loan his lands to the Guarani and asked friends to help build up a house there and till the land and plant it with beans and manioc so that when the Guarani moved in they would not have nothing. There L. and his colleague were also able to hide other political activists who were escaping the military.

Rui on Land Conflict #1

"A local businessman bought up fifty acres here. He let the families who had sold their property to him stay on. After three years, he decided the families should leave, but they asked for more money. The amount he had first paid them had seemed like a great sum because it was one big chunk, but it wasn't enough to live on.

"They'd spent the money during those three years and realized they didn't have enough to buy a house in town or another piece of land. That's when the businessman brought in A. as a partner since he had money and another who was a lawyer to help him battle the families in court. They gave the families a little more money and they left."

Footnote on A.

It is said that while A. was the manager of a bank in town, he swindled the bank out of 35 million cruzeiros. Several employees were fired and A. was brought to trial, but never convicted. Later, he went to work at the mayor's office where he made several transactions and accumulated more land.

 It is said his latest deal was to convince an arms manufacturer to set up a missile factory on an isolated and unpolluted beach. The community protested and, for now, it seems he has lost.

Rui on Land Conflict #2

"B. is trying to buy up all the lands here. On his property he has banana and pine trees, and in his house he has gas-heated water and a bathroom.

"A local from the village sold B. his land, which included the beach. When the *Caiçara* sold the property, he told B. that a small plot was to be given to the municipality for the construction of a school. The *Caiçara* did not put this in writing.

"B. is now trying to close the school. The village is fighting the closing. If the school is removed, the beach will become private and we won't be able to get the bananas to the beach on the highway. Our neighbor who sold his lands could help solve this, but he won't testify in court. Both his son and daughter-in-law work for B., and if he testifies, they'll lose their jobs and they'll have to go back to carrying bananas."

Last Day in the Village

On my last day, Senhor Vítor asked me to marry him, saying, "You please me very much. I want you to stay." I said that I could not since I still had to finish art school. He kissed my cheeks and we parted friends.

Rui and I set out for the highway. The seventeen kilometers took us four hours to walk. Just before we reached the highway in the rain, Rui cleaned the mud off his feet in a puddle and then hid himself behind some bushes and put on his US Top Jeans. Along the way, we passed a mansion owned by a descendant of the slave-owning French family.

I got on a bus to town, and Rui, who no longer wanted to live in the village, walked down the highway, looking for work.

Paloma and Evandro

Paloma and Evandro, Rui's niece and her husband, live and work on a plantation in the nearby *sertão* (backlands) across the highway.

The rain forest had not long ago been cut down to make the *sertão*. Chopped-out clearings are edged with trees that threaten to fall. The houses of the wealthier families are near the asphalt road on the flatlands. The houses of the poor try not to slip down the mountain sides while the forest keeps sprouting on their front steps. The owners of the houses in this area are truck drivers, laborers, and farmers with small plots of lands. Scattered throughout the community are farms owned by aspiring Japanese grocers.

Land parcels in the valley cost 120,000 cruzeiros. On the mountainsides, it is 70,000 (the equivalent of about three months' wages). The houses of workers are built of cement blocks. They gradually get plaster walls and gardens. Some of these houses have tile floors.

The plantation lies thirty minutes' walking distance from the asphalt road. In a secluded area, just before the entrance to the plantation, sits the two-story house of the owner, a French engineer, commuting between France and Brazil.

Rui and I passed the gate into the plantation and walked up the hill. Sugarcane grows on the sides of the road. The houses of the five families who work here are well built as well as comfortable in size and with small gardens. The men of these families earn almost two to four minimum wages.

On the plantation, they make *cachaça*. It is not a very large plantation and it is not a profitable business. The owner usually gives the five-liter bottles of *cachaça* as gifts to his friends and tries to interest foreign distilleries in his production.

On the very top of the hill is the sugar mill, which is run by a waterwheel. The mill can only crush one to three stalks of sugarcane every five minutes. The smashed stalks, which had been thrown over the edge of the hill, have now piled up to meet the top of the hill. The sweet juice has made this mound into a nest for every type of insect in the nearby forest.

The screws that hold the mill together are not bolted on. Every half hour, the men must remember to bang in all the screws that are about to pop out. The pipe that carries the sugarcane juice, *garapa*, from the mill

to the still is definitely broken. The men tried to patch it up again, but it did not work. They are using a small cauldron and a rusty tin can with old concrete stuck to the bottom to carry the *garapa* to the still.

The still is homemade. Many of the parts were invented by the manager. He never did put in a barometer to measure the pressure. One day, the still blew up and the roof flew off. No one was hurt, but they lost all the alcohol. It takes three hundred liters of *garapa* to make fifty liters of *cachaça*.

The house of the manager is also on top of the hill, but set away from the other houses. It is painted bright blue with yellow trim and the windows have red and green frames. The manager earns four minimum wages. His house is the only one with tile floors, a sofa, and two armchairs. The house has two kitchens: an indoor one with a gas stove and an outdoor one with a wood-burning stove that his wife prefers.

When I came, Mirna was at the stove, wearing a green flower print dress, a torn gray shirt, and faded brown pants. She had straight black hair tied up with an old rag. All her teeth were black. Like everyone here, she drinks too much *garapa*. She was too old for her years.

Her husband, Gerson, was sitting out in front of the house. He did not get up to greet us. Instead, he had spread his legs when I passed by so that I would see his actually small bulge. He said he had traveled to Mexico, Canada, and Europe. Later, Rui said none of that was true.

Paloma, Rui's niece, is from the same village. She is twenty-one, slim, with green eyes, and very pretty. She married Evandro at eighteen and has two children. Paloma is proud of her house. It has a sink, a gas stove, three chairs, a table, a bathroom with a toilet, and a cold water shower. Although there are two bedrooms, the entire family sleeps in the same room. The other bedroom is used to store clean laundry. The living room is two by four paces. It has room for one armchair that Evandro made from chicken wire and that hangs from the ceiling and swings. Each room has a bare lightbulb.

Evandro earns 50,000 cruzeiros a month (almost two minimum wages). The owner of the plantation pays for the gas and electricity. They do not pay rent on their house. Evandro's wages and benefits are good by Brazilian standards. He spends most of his wages on groceries: rice, beans, meat, coffee, sugar, milk, and feed for the ducks and chickens. Our supper for the first night was one teaspoon of beans, plenty of rice and manioc flour, tomatoes, and two-and-a-half centimeters of sausage.

Their biggest expense is powdered milk for the oldest child. The Nestle Nestogeno milk costs 1,050 cruzeiros a can. It lasts four days. Paloma gives her daughter five bottles a day. She mixes three measuring cups with a bottle of water for her two-year-old daughter.

The label on the Nestle Nestogeno can reads:

Age	Water (ml)	Cups	Bottles	Soup or Cereal
1–2 wk.	110	3	6	
3–4 wk.	120	4	5	-
1–2 mo.	150	5	5	-
2–3 mo.	180	6	5	-
3–4 mo.	210	7	5	-
4–5 mo.	210	7	4	1
5–6 mo.	210	7	3	2

The two-year-old girl is being fed 210 milliliters of water to three measuring cups of dry milk. This is enough food for a one- to two-week-old baby except the imaginary baby gets fed one more bottle a day. Paloma said it is very sad when she is breast-feeding the baby boy and the girl comes up to ask for some, but she cannot give it to her. She said her milk was better than powdered milk because the baby is fat and the little girl is skinny.

Nestle now also agrees; the label now says that breast-feeding is the preferred method.

I did not tell Paloma about the right amount to feed the girl. Paloma would not have been able to buy more milk, but she would know for certain the girl was malnourished.

Evandro is looking for a better job. He said it is difficult since he is supposed to work all day and it did not leave him time to walk to town.

I went to see the men working in the fields. They cut down the sugarcane, then carry it on their backs to the mill. The fields are littered with canes that are spoiled or too thin. To get out of the fields with a loaded back without falling is difficult.

There is some free time during the day and night. There is nothing to do with the free time. If you are not working, the only thing to do is to wait for night to come. The only thing to do before night comes is to drink. At the plantation, the men come home for lunch already drunk. They sleep then go back to work. They return for supper, drunk.

On the second day, I went to the still. The manager gave me a shot from the first batch to come out. I could only take a sip because it was far too strong. By the sixth batch, I had to go back to the house. When I got there, Paloma was happy to have someone to talk to and offered me a double shot of *cachaça*, saying, "The men have left, now let's have a drink."

Later on Rui, Evandro, and I went to the bar. There was a young boy there who was the waiter. He had thick black hair, dark skin, almond eyes, and slightly buckteeth. Evandro and Rui complained about the loud disco music played at the bar. The young boy answered back saying that he was not a *Caipira* (in this instance used as a derogatory term for someone from the countryside). The implication was that we are and do not know what good music is. Evandro told the young boy, "You are the king of the *Caipiras*." Rui asked him where he was born and what was his name. He'd been born in the *sertão* and his name was Cafoné. (*Cafoné* means the caresses you give someone on the head and nowhere else.) Rui said, "So what could be more *Caipira*?"

When we got back, Evandro and Rui went to work and I went to sleep. Later on, we were going to a party. After work, Rui and Evandro came home very drunk. They still kept drinking until it was time to leave for the party. In front of his wife, Evandro asked if he could sit on my lap. I quickly got up to help Paloma cook dinner. He said aloud that it was delicious just to see me frying the egg and he knew it would have a different taste than the ones his wife cooked.

At the party, Evandro kissed every woman he danced with. Paloma remained calm and collected.

On the sofa, resting from dancing, was a working mother who is single. She is a maid, cleaning four houses a day. The first thing she does when she gets home is drink *cachaça*. She said she cleans house for a German man. She said Germans are not so cold like we thought. He likes to see her dance the samba while she cleans for him. She also said one night Gerson told her he needed a good woman beneath him. He complained that his wife was too weak. Gerson never takes Mirna anywhere.

Evandro was too drunk to leave the party, so we left him there sleeping at his niece's house. She is nineteen and has two children. Her peasant husband is shy and does not like to dance. He is nice and lets her dance with other men, Paloma said.

We then started back home. I carried the two-year-old girl. The manager and Rui walked in front. They were both drunk. They would

walk to the left and fall off the road, get up, walk, and fall off the other side of the road. I was following Rui so I would not have to pick out places to step because even if he was drunk, he could still see better than me in the dark. He walked through a puddle. I splashed after him, forgetting to check for reflections of the moon on the water of the unlit road. Since the little girl was far below the average weight for her age, I was able to carry her all the way home. The men complained that we were walking too slow.

Evandro banged at the door at five in the morning and shouted, "Paloma, they'd told me you left the party very late. They also said you were dancing with other men." From the other side of the locked door, she said, "Rui and Gerson left with me. It was ten. I didn't dance. You're too drunk. Why didn't you sleep there until the morning?" He yelled, "You left late." She said he should go to sleep and he could yell at her in the morning.

In the morning, he sat in the living room, too embarrassed to talk to Paloma and me.

Rui said, "Quando pobre morre é pinga que matou. Quando rico morre é o Pai do Céu que levou." (When a poor man dies, it is drink that took him. When a rich man dies, it is the Heavenly Father who took him.)

The Overseer

There is a ranch so large in the backlands that there are enough hired hands and their families living on it to have two schools. The new teacher went to speak to the overseer of the ranch and explained that she will be giving regular classes to the children and will also be able to offer additional classes either for the pre-school toddlers or literacy classes for the adults. She asked him to talk about it with the community to see what they would prefer.

The overseer said he would call the owner to see what he wants. But that is not what the teacher had said—she requested that he speak to the community. The overseer said he thought that classes for the pre-school children were best because that would free up the women to work on the ranch, and literacy classes were a bad idea because then the farmhands and their women would learn to read and write and they would leave for better jobs. I asked the teacher why she did not challenge the overseer and she replied that she would have to live with these people for several years and they have complete power over her and her job and can decide to accuse her of anything.

A COASTAL TOWN
IN SOUTHERN
BRAZIL

A Family Incognito

Senhor Paulo left his hometown in 1964 very suddenly. He was a union leader in a small town. Everyone knows everything in small towns. The Black Maria (police) van came for him while he was at the union hall, but he was able to escape by walking across the rain forest into a new town and life. He sent a warning to his family to leave that very night. They moved to a town on the coast in southern Brazil.

He went there to start a new life. He could not use his work papers. He could not let the new boss know he was literate or he would be asked for his work papers. He could not show his work papers or they would come for him.

He got a job as a day laborer with no guarantees or benefits. He had a wife and eleven children. He had lived in a comfortable house with electricity and running water. Now he started a new life with his family. He built a new home. The new house is at a corner of the main avenue in town. Hot-rodders race up and down this street. The house is five steps wide by ten steps long. It is built from scrap wood.

The parents sleep in a back room where there is a bed and three wooden crates to put clothes in. The two younger girls sleep with their parents. They work too many jobs to be able to make love. There is no money and there are eleven children. In the other room, seven children share three bunk beds and a car seat.

When you sleep at night on the top bunk bed, the sun-shrunken boards of the walls and ceiling let in the cold night air, which you try not to allow through the thin blanket. You can try not to feel the rain and cold, but the headlights of the cars give you bad dreams. And the chickens, which are allowed to sleep in the house during laying season, wake you up with a start.

The shower and the toilet are outside in a small shed with no ceiling or door, but a wobbly fence gives you some privacy. The young girls of the house shower there. It is easy to see their bodies from the sidewalk.

In the back of the house, there is a large room. This place is rented out to another family, but they are too poor to pay money for it. I never saw them, but I heard their children playing and smelled their food cooking.

The nine children still living at home and the parents drink tea for breakfast because coffee has become too expensive. They eat rice for lunch and rice with an egg every other day for supper. Sometimes there is macaroni with margarine.

Senhor Paulo

Senhor Paulo works as a stone breaker for the city on weekends. The stones are used to decorate the sidewalks with starfish, seagulls, and seahorses.

Senhor Paulo has been active in politics for a long time. "I began when I was in my twenties and I didn't know about politics. I was in the Integralista Party (a fascist party of the 1940s). They gave me a free subscription to their paper for one year. But when I saw what they were saying were lies, I stopped participating in the meetings.

"I joined the union, held several positions, and was elected president for two terms. The Integralista Party invited to me to another meeting. We were to vote for a demonstration against Fidel Castro because he wanted money in exchange for the American soldiers (who participated in the invasion of Cuba) whom he held captive.

"They let me speak and I asked, 'Has Fidel Castro killed sugarcane workers? Has Fidel Castro persecuted unions? Or has Fidel Castro simply demanded money for the mercenaries who invaded his country?'

"They did not know what to say, but they didn't vote for a demonstration against Fidel Castro. They got it voted in some other places, but not in our town.

"Once for the May Day celebration, I organized a party at the union hall. But the bishop was in town and another party was organized for him. There were a whole lot more people at my party than at his. People would go to his party and leave to stay the rest of the night at mine. Later in the evening, the bishop came to the union's party. I organized a committee to greet him as soon as I saw him come in. The people opened the way up for him and kissed his hands. Then I came up and kissed his hands like the rest were doing and sat him at a table. He didn't know I was president of the union. The bishop told us he wanted a communism with God. I said I also wanted communism but it didn't matter who it came from, God or the devil. As long as it was communism, it could come from the depths of hell."

In the mid-1950s, Senhor Paulo and his friends were excited about the struggle in the state of Mato Grosso do Sul. He and his party thought the revolution was going to be made in the town of Francisco Beltrão. He and a *companheiro* went to do political organizing there.

The house they slept in was infested with the *barbeiro*, an insect whose bite can lead to severe heart damage within years. They quickly headed into town to buy some insect poison to sprinkle on the bed. As they were doing this, the woman of the house was peeking through the cracks of the mud walls. Thinking it was the casting of an evil spell through *macumba*, she became frightened. The next morning, the worried woman asked what they had been sprinkling. Paulo explained that it was for the insects, but she had gotten so used to them, she did not even see them and did not know they could kill you.

Senhor Paulo said the army in Francisco Beltrão would throw children up in the air and catch them on the tips of their bayonets. He and his *companheiros* also did some wrong things, he said. He tells of one old man who was walking home and took a ride from soldiers in a jeep. The old man's son saw him and thought his father was turning him in. When his father arrived home, the son said, "Those who dream about acres of land get seven palms worth of it." The son killed his father and buried him in seven palms of land (the measurement needed for a grave). The son later found out that his father had just accepted a ride and was not turning him in.

Senhor Paulo explained the results. "Because of the struggle there, they were able to remove all the local politicians and replace them with opposition people. We were fighting for land reform in Francisco Beltrão, and the opposition people were put in power because of our efforts and our lives, but it did not result in land reform. There was no state or federal army to support us and no social changes could take place because the landowners had too many hired guns."

It's Sunday, the radio is on, and a preacher announced that we need to work well for the employers and exhorted the listeners not to join the union or political parties other than the government party because all the other parties were communist.

Senhora Ágata

Senhora Ágata runs a grocery store through the front window of the shack she and Senhor Paulo live in. Once she overcharged an American who had bought a coconut. She asked if it was all right. I said he would never know the difference. (The amount was so small.) She was relieved.

Senhora Ágata's father was a gravedigger. "We lived next to the cemetery, but I was never afraid. When I was seven, I would help my father with his work. I would take candles and flowers from the graves of the rich people because there were always a lot there, and I would then put a lit candle and flower on each grave because the earthen ones with wooden crosses had no flowers or candles. The job was harder when the wind blew. At night when there was a moon, it was sad to see the statues of saints on the graves because you were reminded of how many people were dead. When I did these things, I was never afraid, but after my father moved from there, I would wake up at night sweating. The dead people were asking me why I hadn't put any flowers on their graves, and where were the candles? They wanted to know if I had forgotten them.

"I made friends with a gravedigger here. I always talk to him about funerals. He thinks I'm strange. He said every time he digs up a coffin, the corpses have their backs turned up. He said how big the worms in the coffin were.

"When I was young, there was an ice cream store owned by Italians. I like ice cream, so I went to work there just to eat ice cream every day.

"Then I wanted to eat meat every day so I went to work at a butcher shop. The owner gave us one and a half kilos of good first-class meat every day, but then I got tired of eating meat. So I started giving it to friends and relatives. They would always be happy to see me, but it was just because of the meat.

"When I had Helena (the eldest child), I wasn't married, I would go to the city sometimes with the classified ads just to see if I really had luck in finding jobs. I would always get one, but I already had one. It was just to see if I was lucky.

"When I have nothing to do, I visit the hospital. I feel sorry for the people who are going to die. I visit with them. They named me the 'Talker with the Corpses.' One time, I stayed almost every night visiting

an old lady. I visited her for one month, but she didn't die, and I got tired of talking with her, so I didn't go anymore.

"When I get old, I want to go to a home for the elderly because I don't want to give any trouble to the kids. When you're old, you want to tell your stories and the kids already heard it all. But at the home, everyone has to put up with each other's craziness so as to have friends. There you can tell your stories.

"All it does is rain here. It's been like this for months. Every time it rains, Paulo stands by the door shouting, 'Show them, God, how you like your people, give them rain just so they lose a day at work. Show them why they should pray to you.'

"Paulo is like that about God. Once I put a candle out for the protector of children. It was on a windowsill and the candle cracked the pane. Paulo said, 'Now, go give the saints the bill for the pane. See if they'll pay.'"

When Senhor Paulo and I discuss politics, if Senhora Ágata is within earshot, she comes up and tells us to stop. She reminds her husband what politics has brought them. However, she does not mind talking about politics when her husband is not around. He always gets angry at her for supporting another opposition party. She says, "I want things to change quickly. It's no use, these political meetings. It's like a bunch of women getting together to gossip. Next time I'll vote for the Partido dos Trabalhadores [Workers' Party]. Lula [president of the Partido dos Trabalhadores] is young. The younger generation has different ideas about how to change things.

"During the election campaign, I was leafleting outside the school. I asked one woman whose husband earns 16,000 cruzeiros (about half a minimum wage) and whose rent is 10,000 cruzeiros, 'How can you afford to buy the two liters of milk you need for the children?' She said she didn't. But she was still going to vote for the government party. I said she deserved what she was getting."

She held up her hand and showed me the tracks of a parasite that was underneath her skin. She explained that the track had begun near her right index finger in the palm of her hand and had wandered back and forth and it was now just below her smallest finger. She had not removed it because she was waiting to see what it was going to do next. It was a biological investigation.

Senhora Ágata showed me her favorite bird, the *sairá*, the rainbow bird because of all the different colors of its feathers. The *sairá* likes to fly over the sea. She said it likes its freedom.

The Grandparents

Senhora Ágata's mother came for a visit. The grandmother wears her long gray hair in a bun. She is indigenous. She wears a neat dress with a large pocket in front. In this pocket, she keeps her tobacco and pipe. The pipe stem is made from a reed and the bowl from clay. They never fit well so you have to smoke very hard to keep the pipe lit because the rope tobacco is hard and cheap. That day, she got up from her seat and forgot that the pipe was on her lap and not in the pocket. It fell and broke.

We were watching television. Rex Humbard, a TV Christian minister, was saying how much Jesus loves us. The grandmother said, "If Jesus loved us, he would have helped us win the revolution, but we lost." A commercial followed showing the wonderful beaches of Rio de Janeiro. The grandmother said, "Brazil is a good country for foreigners—they have money. For Brazilians, it's shit." She turned the television off.

When she was a young woman, her house was sprayed with machine-gun fire in the Revolution of 1930. My own grandmother has a photograph of a great-uncle in his uniform sitting on a fancy chair with a glass of champagne in one hand and confetti in his hair. He is very proud. This is a victory picture of the revolution he fought for and that was to exclude him later on.

Her husband was the first man to organize a strike in the town, which was the birthplace of the Brazilian Communist Party. He did not know how to do it. So he went to the baker and bought some bread and cold cuts. The public workers came and sat down. While they ate, he explained what they were going to do. They went on strike and some of their demands were met. Her husband meanwhile would also stand outside the mayor's house, shouting curses at him because he did not know any other way to fight him. He would be sent to jail every time.

Helena (Senhora Ágata's child) said both her great-grandfather and grandfather died saying things were going to change and get better because they could not get worse.

The Children

Helena is the eldest. She says how pretty her sisters are because their father, her stepfather, is white. Helena's was Black and so she is mixed. But they all have the same grandmother who is indigenous.

At thirteen, Helena made love to Ronaldo. At fourteen, she had his child. She hitchhiked to the hospital by herself to have the child. Ronaldo told her she was a whore. He finally married her. When he gets drunk, he tells her she is a whore because she had made love to him and had a child before she was married.

Helena teaches school until two in the afternoon. She comes home and cooks lunch then cleans the house, washes some clothes, and takes the five o'clock bus to the university, which is two-and-a-half hours away. She comes home at two in the morning. She wakes up at six to get ready for work. On weekends, she makes sweets to sell.

She wants to be a botanist, but she does not have enough money for the tuition fees. Instead, she studies literature. She is thin and pretty. Her husband does not let her go to the beach by herself. He does not let her wear a bikini. He makes love with his students.

Ronaldo, her husband, teaches school, drives a cab until early morning, works as a security guard on weekends and other odd jobs.

They make enough money to have coffee and bread for breakfast; rice, beans, and either an egg or meat for lunch; and leftovers for supper. One day, when I was at their house, the dogs and cats needed food and I found some bacon and shredded it for them. Helena came home and said that the 250 grams of bacon I had given the pets was their meat for the week.

Her brother Luciano is in the Marines. He told his parents he was leaving for the Marines only on the day he was due in the barracks. He was glad he went, he said, because he was excited about putting on a uniform. After a week, he was bored. Now, he cannot wait to get out of the Marines. He is paid 15,000 cruzeiros monthly (about one-half a minimum wage). He has leave on weekends, so he has to pay for his own food and board for three nights out of every week.

Another brother, Rafael, is sixteen. He goes to school and sells hotdogs. One day, during the surfing competition while we were talking about politics at his makeshift hotdog stand, a surfer came up and

asked for a hotdog. He wanted Rafael to give him a discount because he did not have much money. Rafael asked him why he was broke. It turned out the surfer did have more money, but he was saving it to buy gas for his car. Rafael had no money to pay someone with a car to transport his pots and pans back to the house at night, so he slept on the beach. In the morning, his mother or one of his sisters would come by with breakfast. Rafael likes to talk about politics, but he says that he does not want to get involved. He is worried that the same thing will happen to him that happened to his father.

The older boys work as farmhands or in the market. Most of the girls are never around much because they usually hire themselves out to clean houses or to babysit. The youngest, Lívia, has said she wants to join the Marines like her brother and then become a journalist. Lívia used to help her mother sell sweets in the streets, but now she is older and is too embarrassed to be seen doing this because her classmates taunt her about it. She has been expelled from school several times for beating up other kids. She has explained that either they tried to bully her or were supporting the military government.

Senhora Ágata has told her children to respect those who respect you, but if they do not then you should defend yourself.

Strategies for Survival

One of the younger kids got the idea to raise rabbits and sell them to fancy restaurants. He was quite successful in breeding them, but when it came time to sell them to the restaurant, a discussion began about what would happen to them there. The kids took all the rabbits to the forest and freed them.

Another idea was to catch wild guinea pigs in the rain forest and make a corner barbecue stand. The guinea pigs were caught and later freed.

Two turkey chicks were purchased. Turkey meat is a delicacy here. The idea was to raise them, keep the chicks, and sell the grown ones to a rich family for Christmas. There is no real fence around the house, and the kids were constantly sent to find the wandering birds. The female was finally stolen. The male was never sold. It sits on the sofa in the living room, usually next to someone for warmth or else in front of the TV. The turkey thinks it is a fire and tries to get warm, Lívia explained.

Plans for a female goat were changed after she was named Raisa (in honor of Gorbachev's wife) and became Lívia's friend, never leaving her side.

Senhora Ágata makes delicious coconut sweets. She must pull out this sugary candy while it is still very hot. She burns her hands every time. She shrugged and said, "They are smooth like a rich lady's. No calluses."

Clementina

Clementina is a 105-year-old woman from a now-fashionable beach resort town.

"Nothing good comes from the sea," she said.

"When I was a young girl, living with my father on the farm, we would make hats from banana leaves and my father would go to the market in Angra dos Reis and sell them to the slaves.

"I married only to suffer. I have never done wrong to anybody. I have been quiet. Now, I only have my daughter. None of the other children visit me. I raised eleven children. My husband would beat me. He would not tell me why he beat me. If I would spend a little too long at the grocery store, he would beat me.

"We had a farm, but for money he'd go to work at the banana plantations a four days' walk from here. He would work four or five months without coming home. I lived by myself in this forest with a house full of children. There were only two neighbors and they lived far away. When night came and the baby would cry, the oldest boy would tell me to put my breast in the crying mouth. It was to quiet the baby. We were afraid that an *onça* (jaguar) would hear it and come to eat us. I raised eleven children in this *depredido* ('dangerous, infertile, and God-forsaken hellhole,' the dictionary says).

"I would lock up the children in the house and go hunt *tatu*. (armadillo). I'd go with the dog. It would find the *tatu* and I would hit it with a stick until it was dead. I'd lock up the children and walk along the rocky coastline hunting fish and looking for oysters. I would cook the oysters with green bananas.

"I had to make manioc flour by myself. I had to grate and turn the wheel at the same time. I had no presser for the manioc. I would pile up heavy rocks on the baskets to get the poison out.

"I would catch birds. I could make a soup with three birds. I liked to work with a hoe. When I worked with it, I could forget about hunger. I would work straight through. Today, the lazy women who come and visit me say, 'Oh, I'm so tired. I don't want to wash the clothes.' I don't like to listen to these lazy people.

"Today, young people don't work. All they do is go to bars. Everyone is vain. They don't care about how you think or what you do—only how

you dress. Everyone spends money on clothes. They want to see your fingers to see if there are diamond rings on them. They want to see your neck to see if there are gold chains on it.

"I am glad to have outlived my husband and to have seen him die.

"I have suffered much in this life. Now I am good for nothing. I cannot work. I cannot walk. I cannot piss. I cannot shit. There is no reason to stay here."

When I returned home for this project and asked, "What do we want the world to know about us?," the people whose stories are in this book generously responded. They told me their stories, suggested people to talk to and photographs to take, and gave me constant physical and mental support. My gratitude is deeply felt and my respect is immense. I would also like to thank Christine Osinksi, Larry Fink, and Brian Swann, who were my mentors while I was a student at Cooper Union, and Michael Taussig, for encouraging this book's publication.

Poems by Maria Thereza Alves appear on pages 152, 183, and 195.
Printed in China by Four Colour Print Group
First edition, 2018

Designed by Matt Avery/Monograph
Composed in Atlas Grotesk; designed by Kai Bernau, Susana Carvalho, and
Christian Schwartz, and Dala Floda; designed by Paul Barnes, Ilya Ruderman, and
Ben Kiel

Requests for permission to reproduce material from this work should be sent to:
 Permissions
 University of Texas Press
 P.O. Box 7819
 Austin, TX 78713-7819
 utpress.utexas.edu/rp-form

♾ The paper used in this book meets the minimum requirements of ANSI/NISO
Z39.48-1992 (R1997) (Permanence of Paper).
Library of Congress Cataloging-in-Publication Data

Names: Alves, Maria Thereza, 1961–, author, photographer. | Taussig, Michael T.,
 writer of supplementary textual content.
Title: Recipes for survival / Maria Thereza Alves ; foreword by Michael Taussig.
Description: First edition. | Austin : University of Texas Press, 2018.
Identifiers: LCCN 2018003970 | ISBN 978-1-4773-1720-4 (cloth : alk. paper)
Subjects: LCSH: Working poor—Brazil—Paraná (State)—Pictorial works.
 | Working poor—Brazil—São Paulo—Pictorial works. | Brazil—Social
 conditions—1964–1985—Pictorial works. | Documentary photography—Brazil.
Classification: LCC HD8289.P373 A48 2018 | DDC 305.5/690981—dc23
LC record available at https://lccn.loc.gov/2018003970

doi:10.7560/317204

MARIA THEREZA ALVES is a Brazilian-born artist descended from the country's indigenous, African, and European peoples. She is best known for her award-winning work *Seeds of Change* (1999–ongoing), which links the environment and colonial history. One of the founders of Brazil's Green Party in São Paulo, Alves received the 2016–2018 Vera List Center Prize for Art and Politics, awarded to artists who take great risks to advance social justice in profound and visionary ways.